U0064765

Contant

MEI GIRLS

×

2020

蕾拉
Lyla

instagram : @la.112814

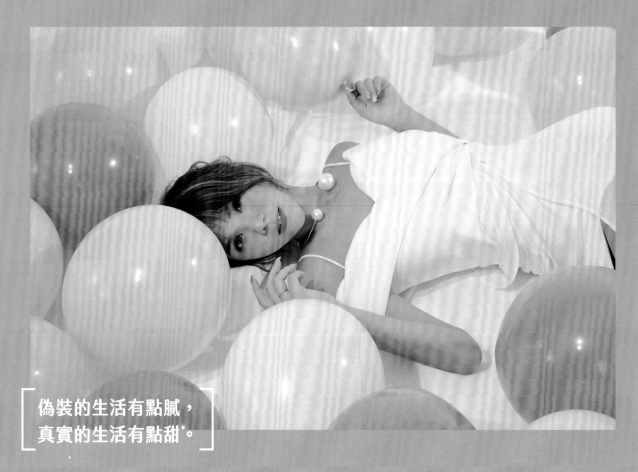

偽裝的生活有點膩，
真實的生活有點甜。

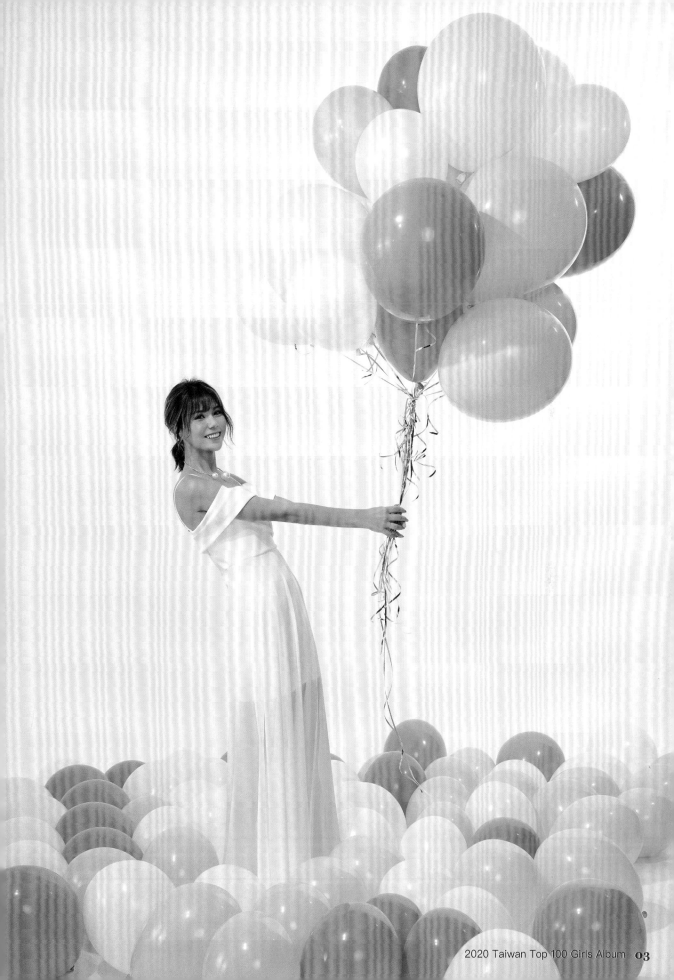

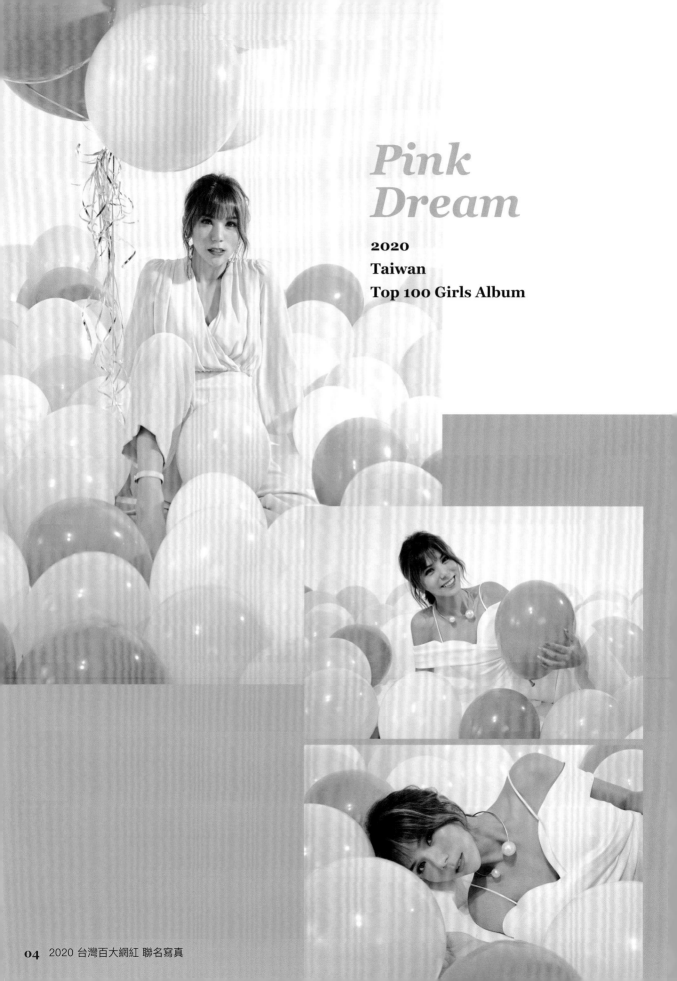

Pink
Dream

2020
Taiwan
Top 100 Girls Album

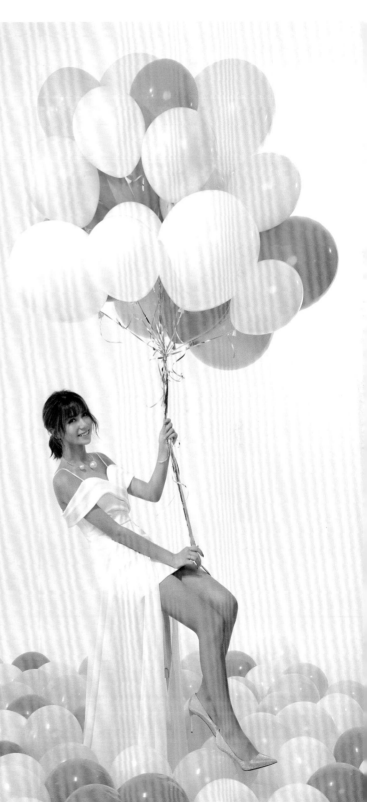

MEI
GIRLS

✕

2020
Lyla

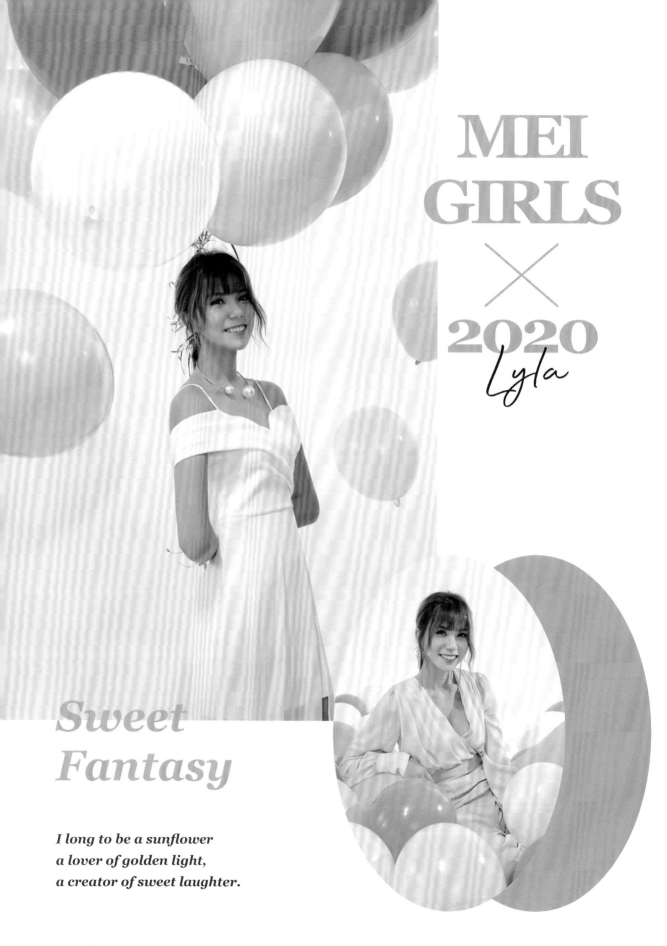

MEI
GIRLS
✕
2020
Lyla

Sweet
Fantasy

I long to be a sunflower
a lover of golden light,
a creator of sweet laughter.

Pretty
In
Pink

2020
Taiwan
Top 100 Girls Album

MEI
GIRLS
✕
2020

美麗妄娜

 instagram : @wanna10_4

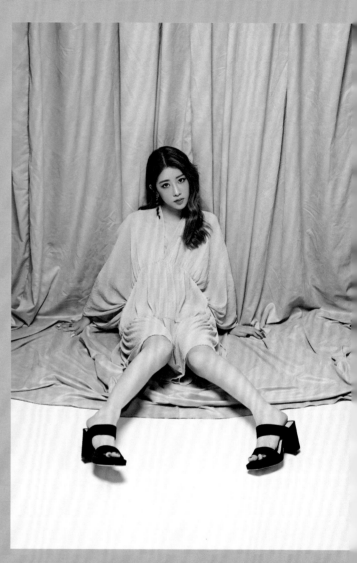

不怕黑只怕不紅，
不怕不紅只怕不夠真。

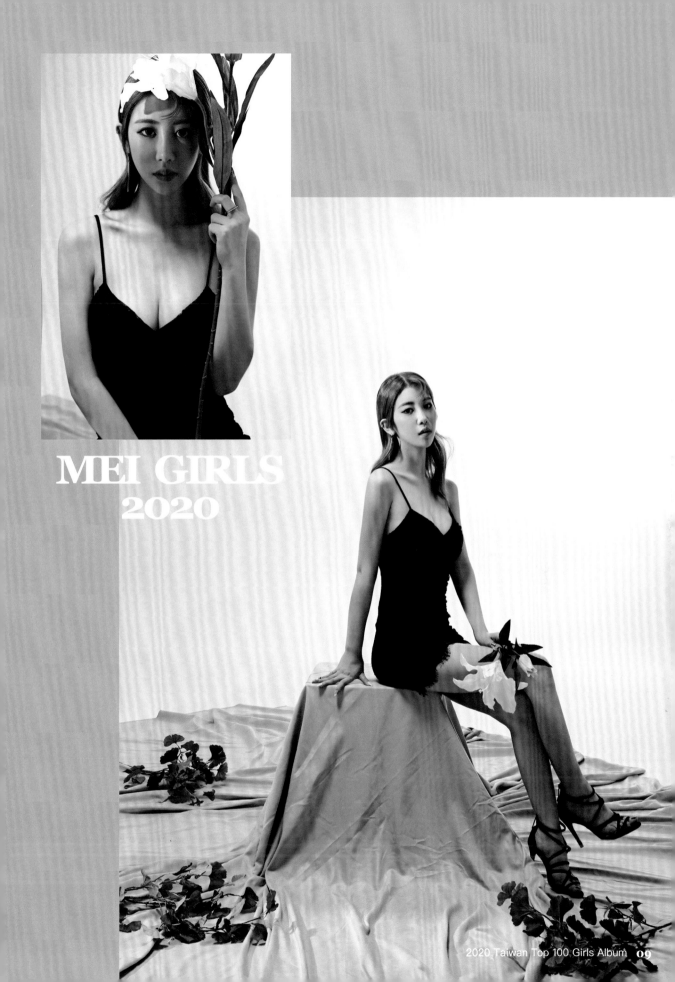

MEI GIRLS
2020

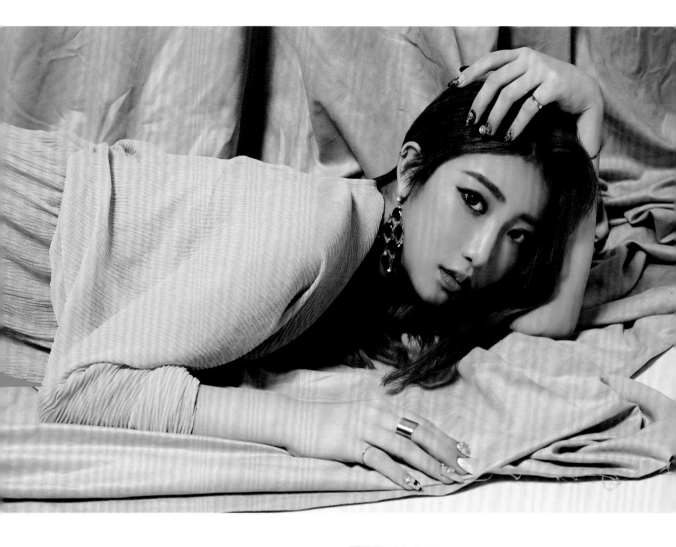

MEI GIRLS
2020

-

Shine Your Light

Blossom
Forest

You'll silently bloom,
Beautifully in your own way

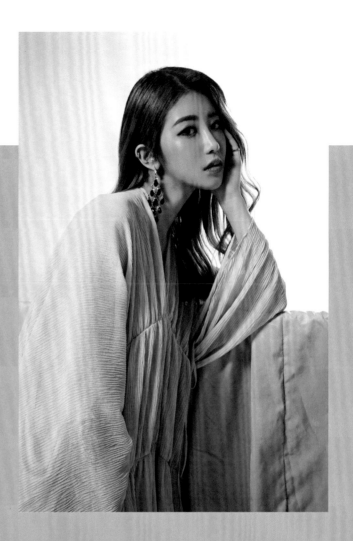

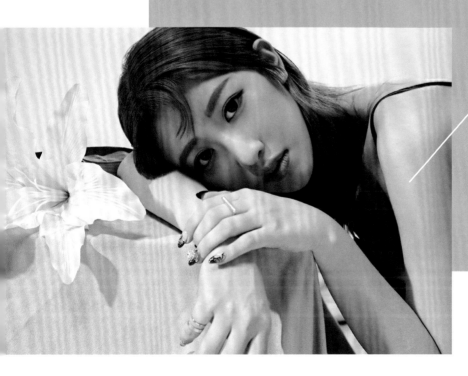

Shine Your Light

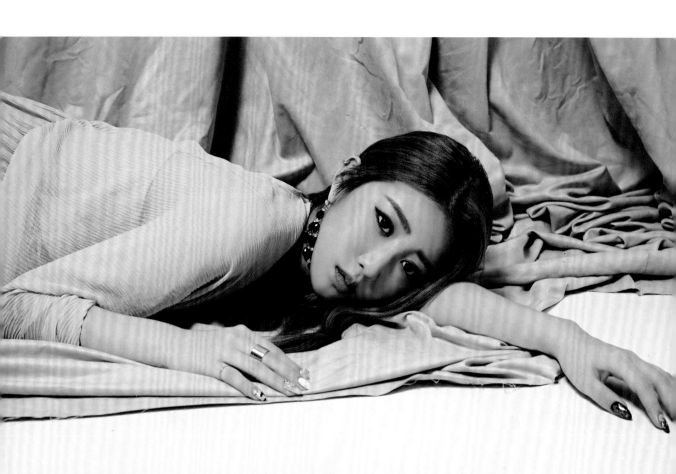

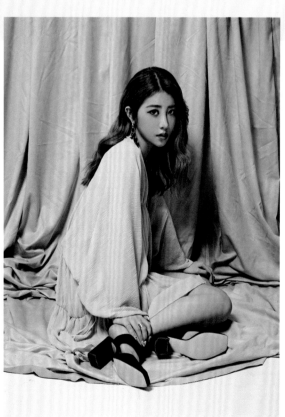

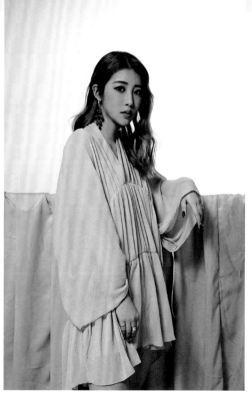

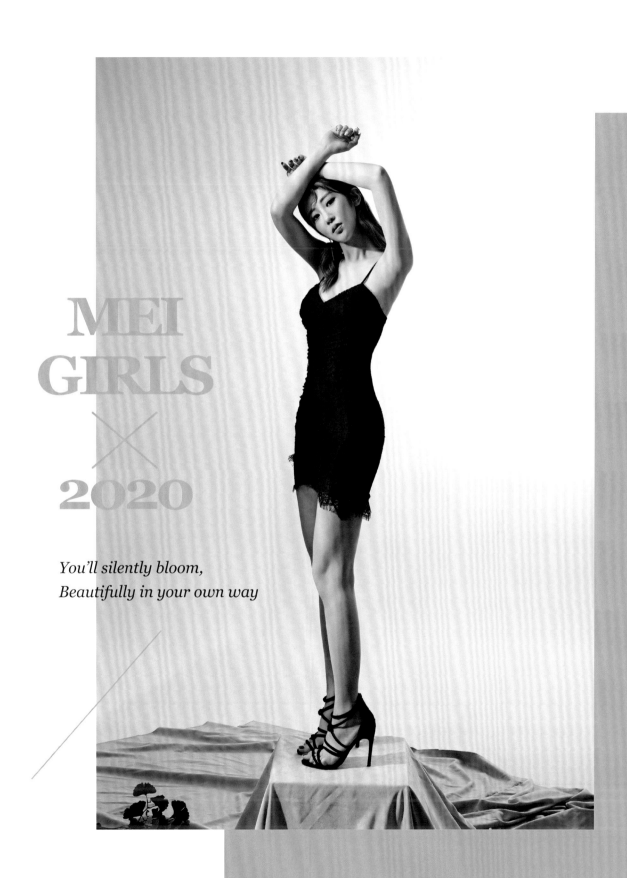

MEI
GIRLS
✕
2020

You'll silently bloom,
Beautifully in your own way

MEI
GIRLS
✕
2020

李小星

DJ Xin

📷 instagram : @djxin_tw

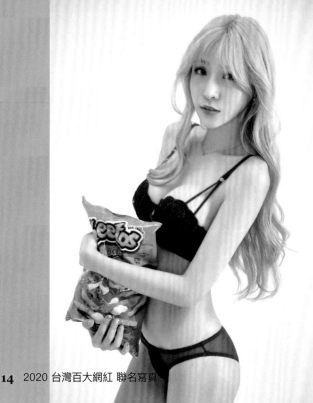

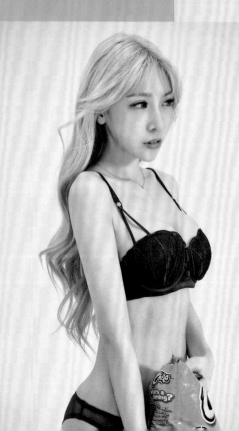

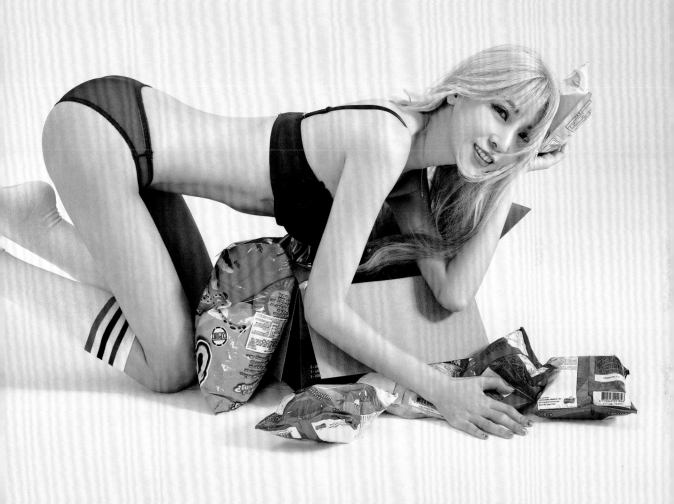

我不是不喜歡這個世界，
而是我只喜歡有你的世界。

MEI GIRLS
2020

Be My
Star

2020
Taiwan
Top 100 Girls Album

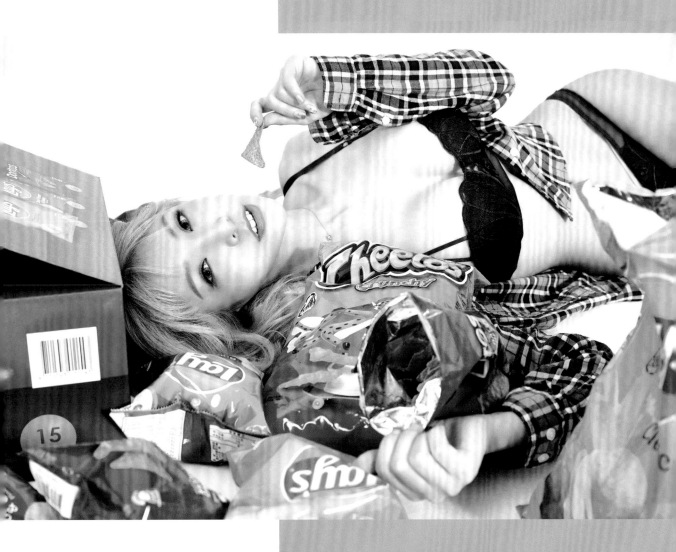

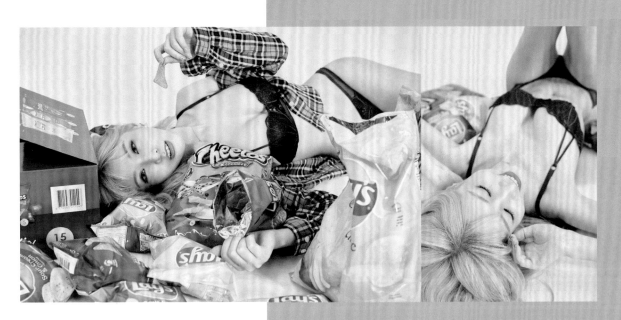

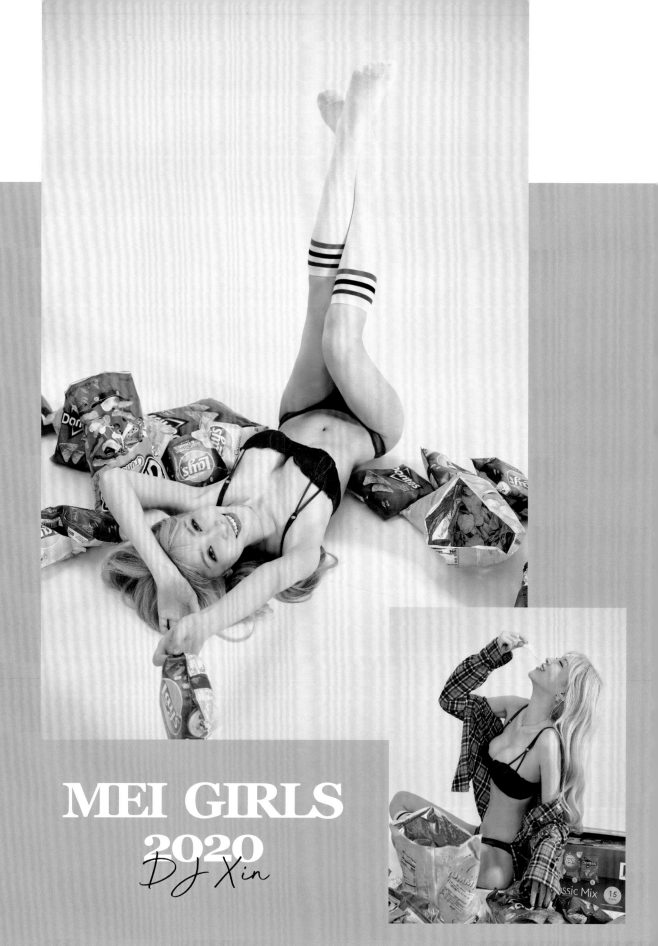

MEI GIRLS
2020
DJ Xin

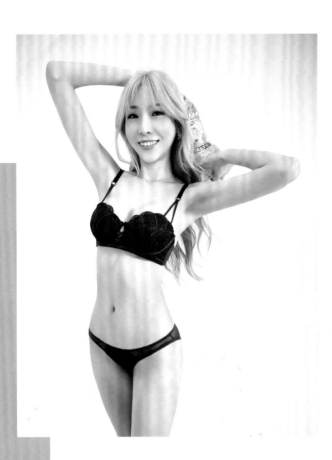

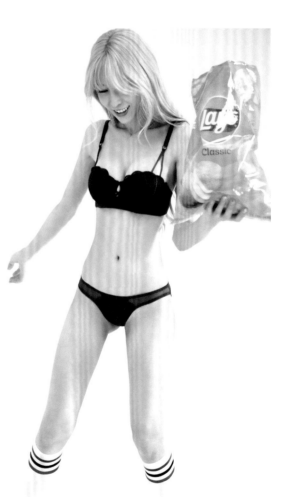

Let Me Shine For You

*You are made
Of stars*

2020
Taiwan Top 100 Girls Album

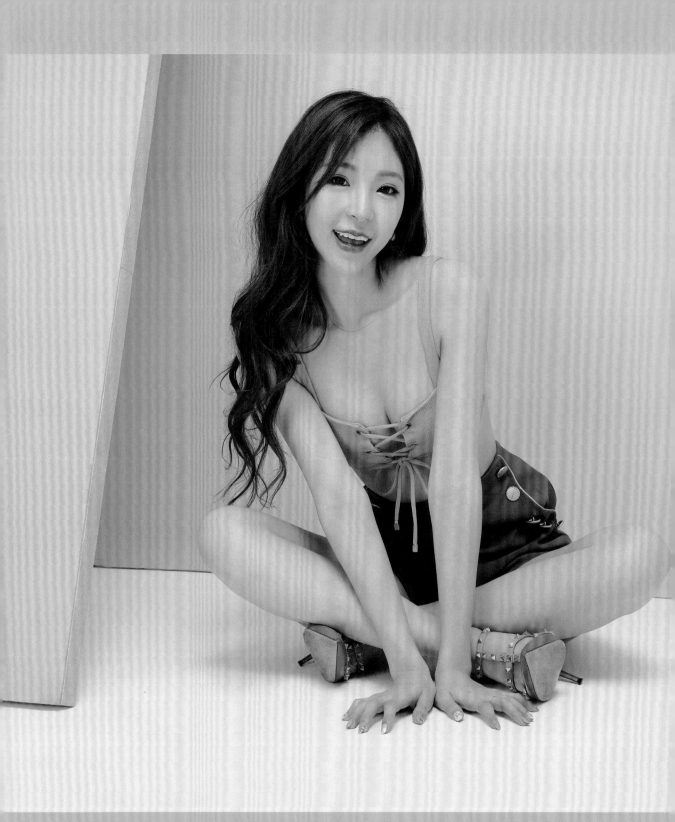

保持善良，莫忘初心。

MEI
GIRLS
✕
2020

采瑄
Ning

📷 instagram : @cutening0976

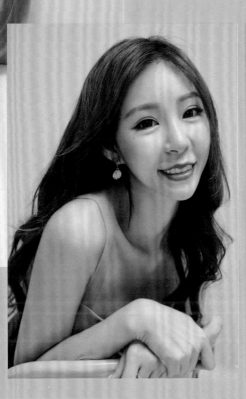
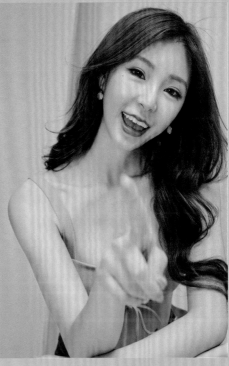

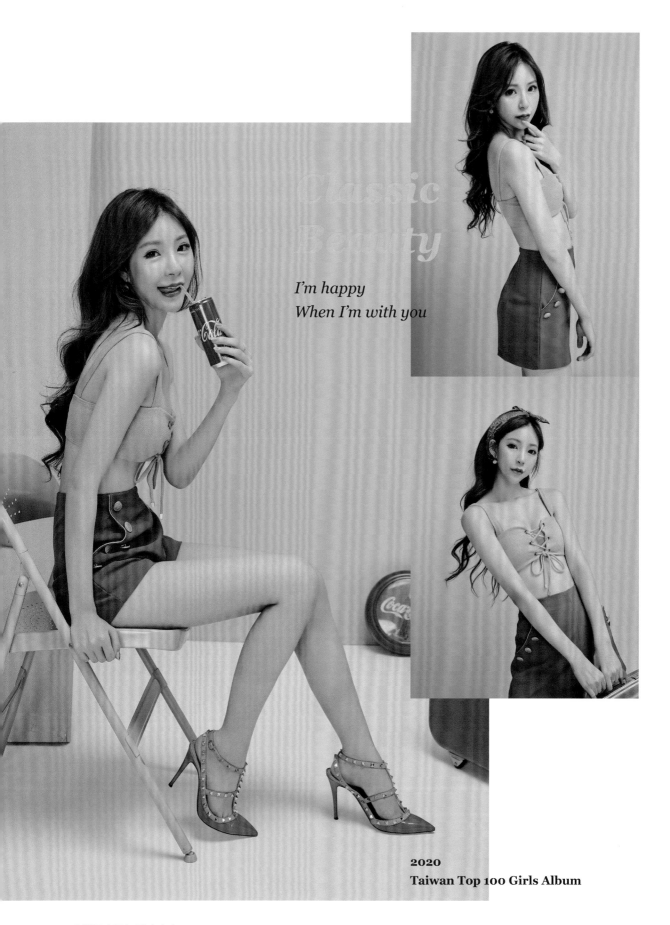

I'm happy
When I'm with you

2020
Taiwan Top 100 Girls Album

MEI
GIRLS
✕
2020
Ning

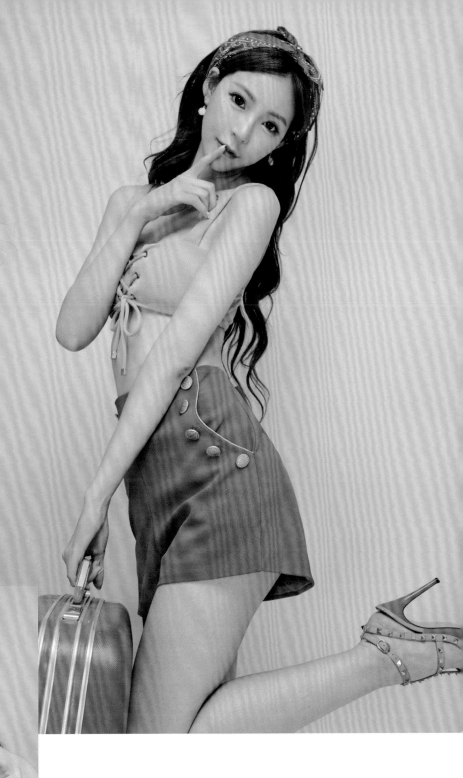

-
Closer To Happiness
Than I've Ever Been

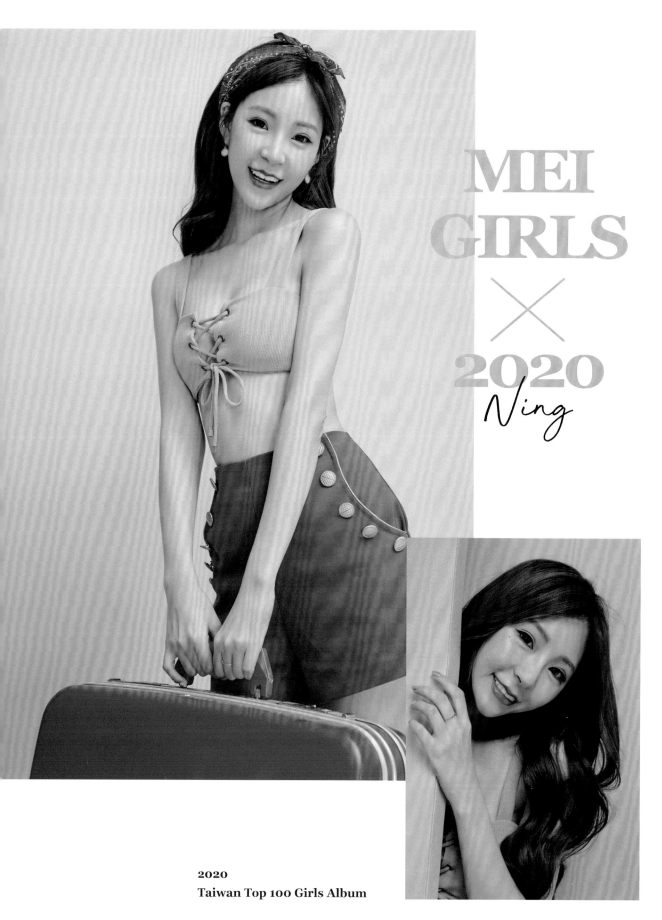

MEI
GIRLS
×
2020
Ning

2020
Taiwan Top 100 Girls Album

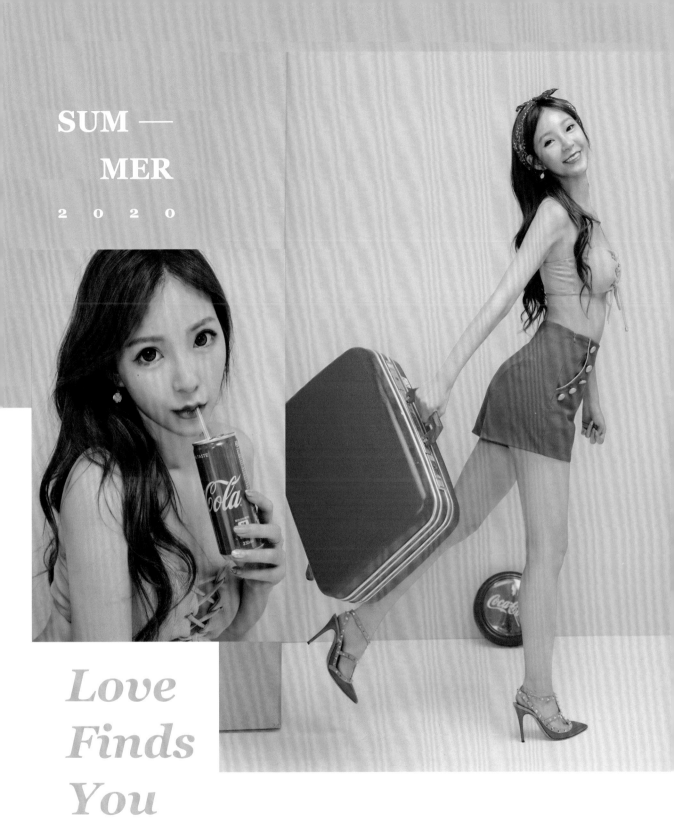

SUM —
MER

2 0 2 0

Love
Finds
You

-

Closer To Happiness
Than I've Ever Been

MEI
GIRLS
✕
2020

啾啾
吳慈敏

📷 instagram：@chuchu0526

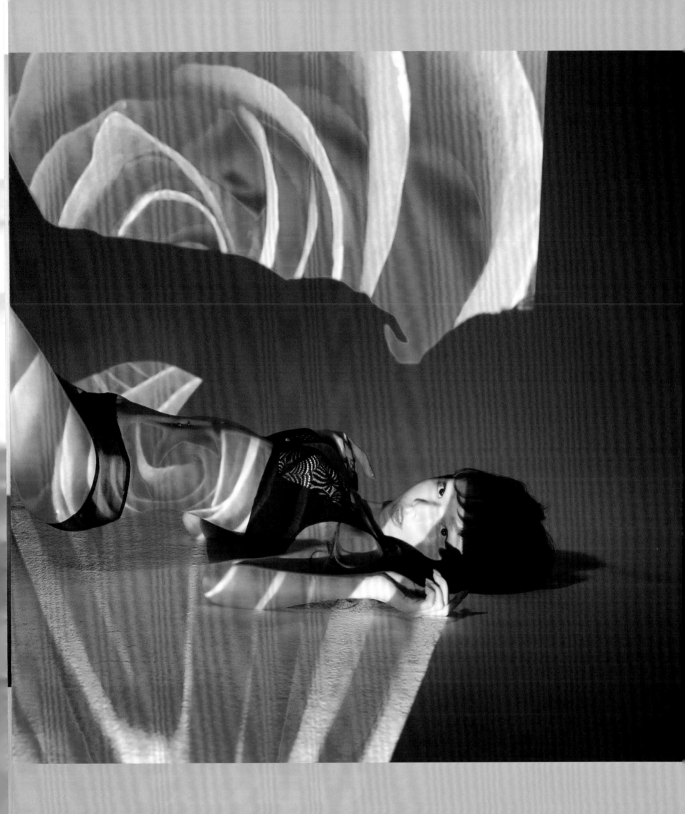

別人都是小仙女，
我是你永遠都得不到的爹。

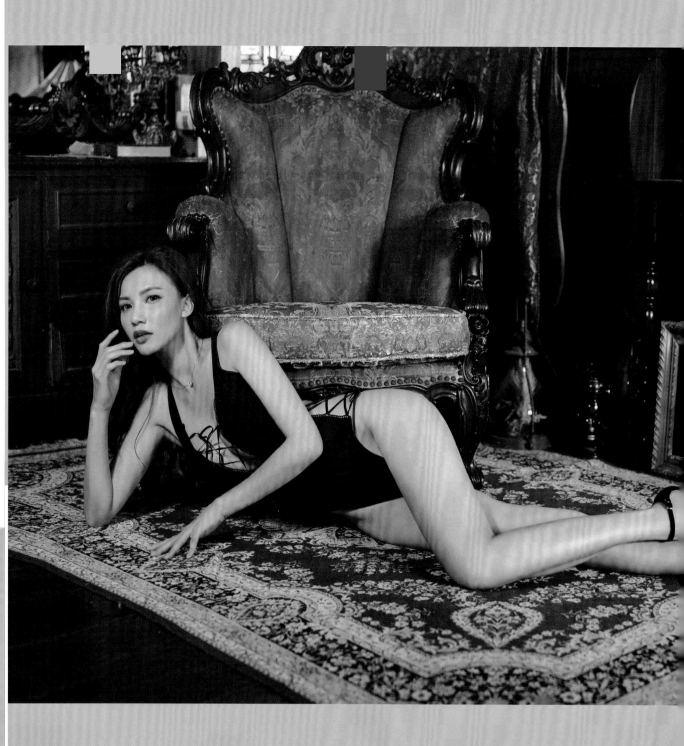

打開你的心，我想住一輩子♥

MEI
GIRLS
✕
2020

蔡譯心

Candice

📷 instagram : @candice0723

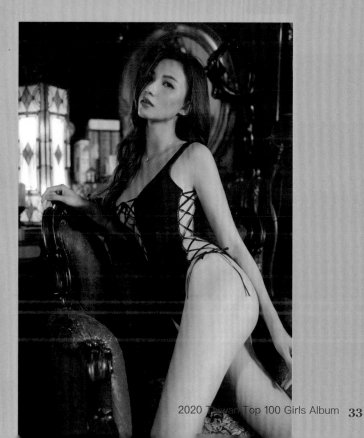

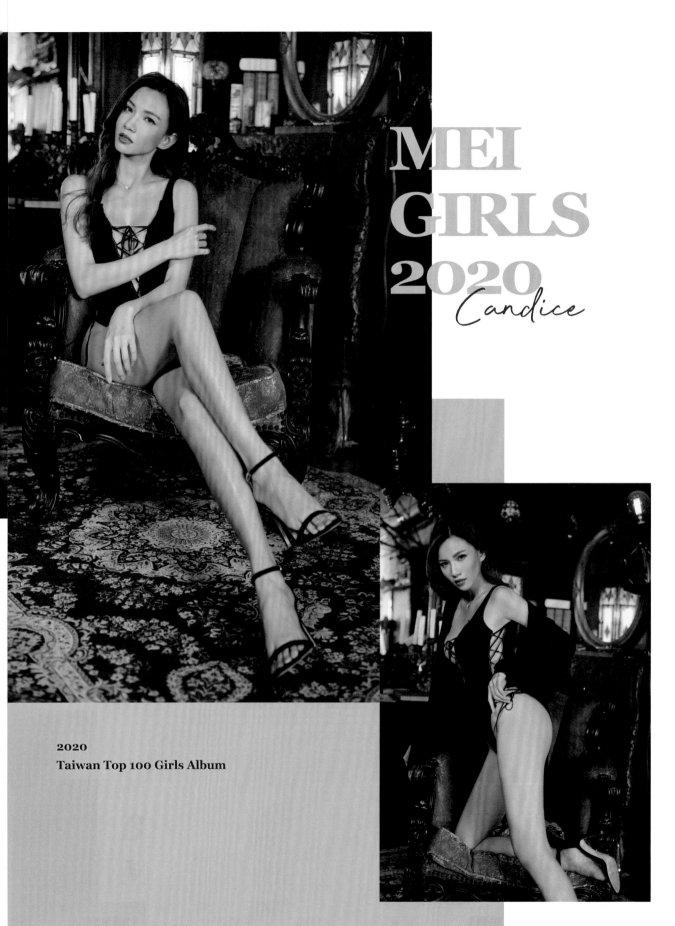

MEI
GIRLS
2020
Candice

2020
Taiwan Top 100 Girls Album

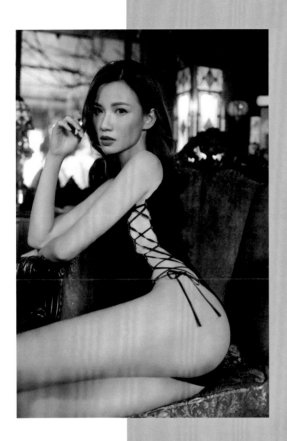
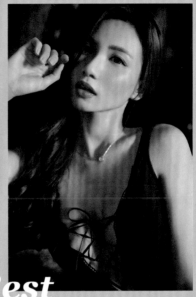

Best Memories

*Take my hand and
my whole life too.
I can't help falling in love
with you*

MEI
GIRLS
✕
2020

李馨

Cin Cin

○ instagram : @cin_cin_li

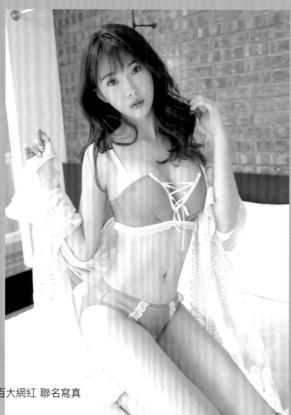

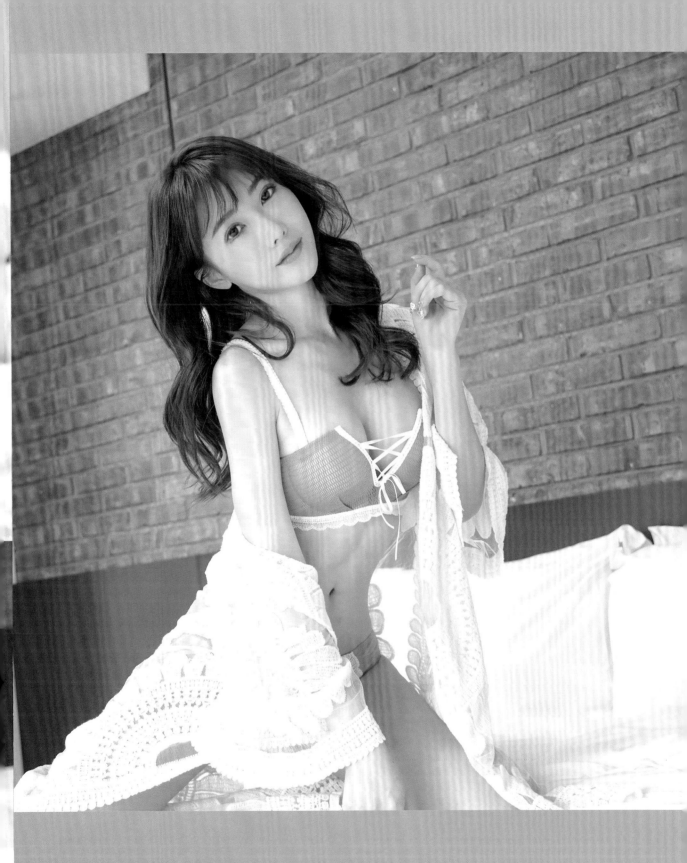

[賞月，賞花，賞馨馨]

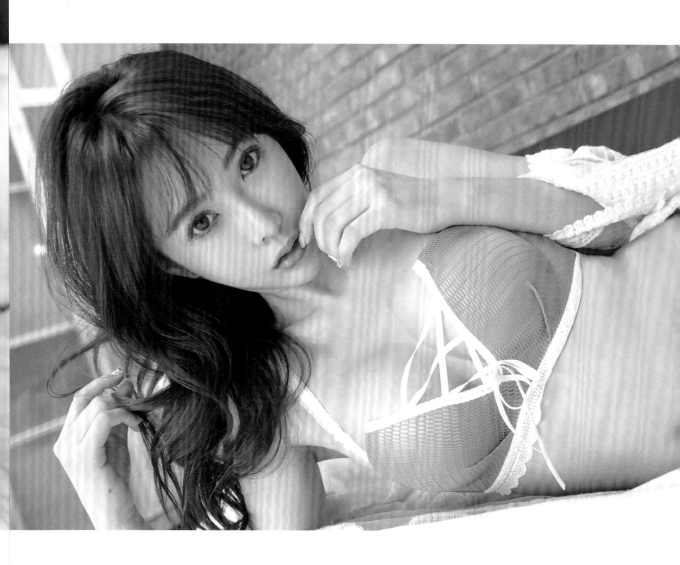

MEI GIRLS
2020
Cin Cin

Waking Up
To
The Sound
Of Love

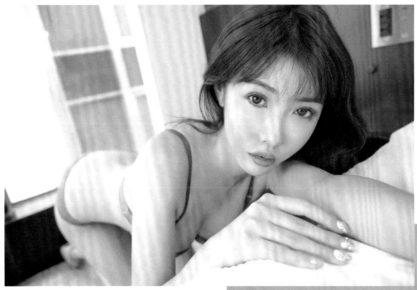

Wake Me Up

I fell for you
And I am still falling

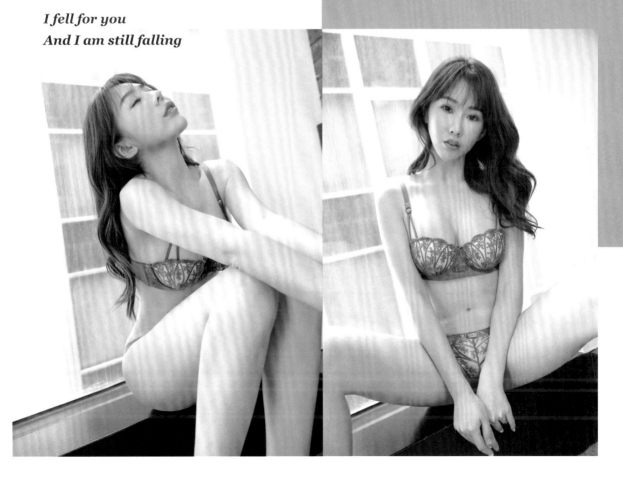

MEI GIRLS
✕
2020

李花
Fa Fa

📷 instagram : @fafaa728

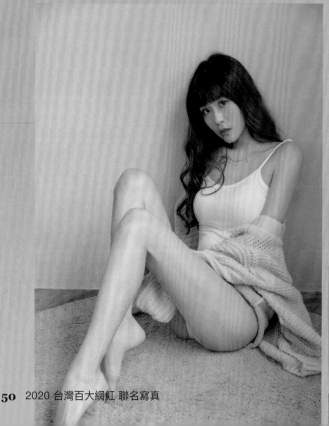

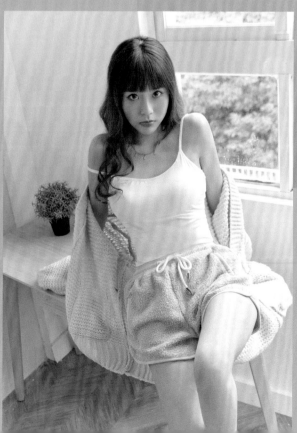

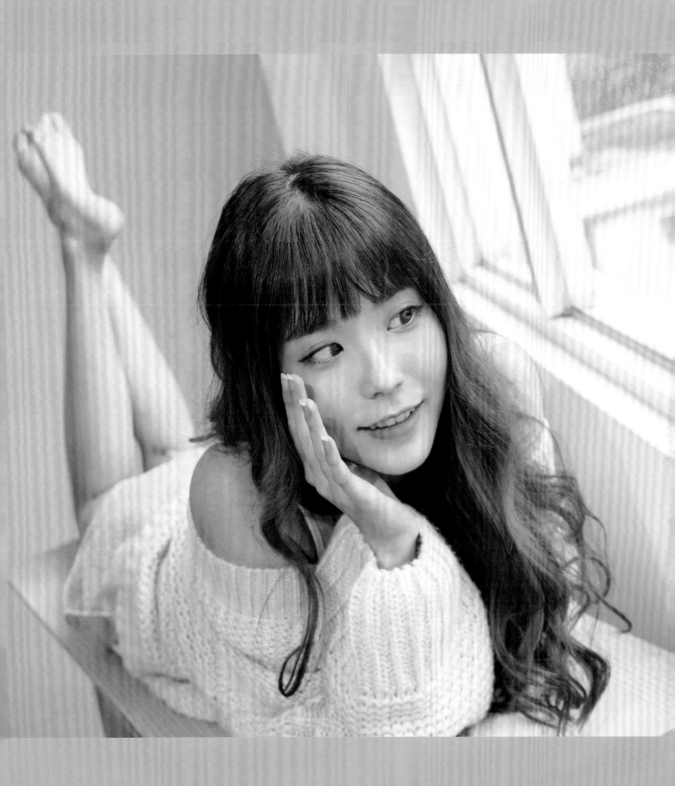

我死後請把我ㄉ骨灰撒進大海，
我掛ㄌ也得繼續浪

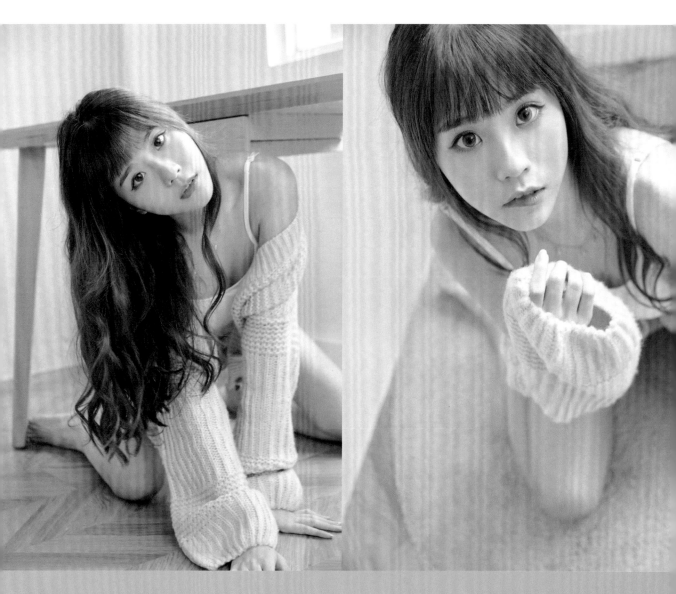
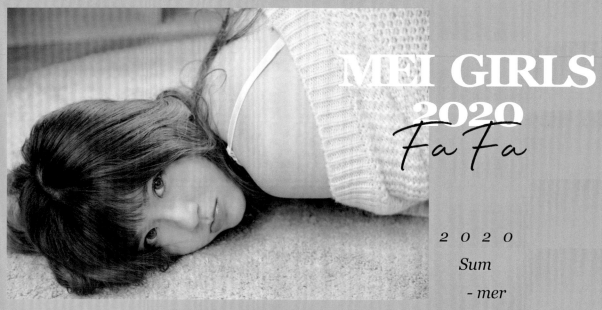

MEI GIRLS
2020
Fa Fa

2 0 2 0

Sum

- mer

Cozy Vibes

Belong with you ,
Belong with me

2
0
2
0

2020
Taiwan Top 100 Girls Album

MEI
GIRLS
✕
2020

青青

📷 instagram：@c.0214

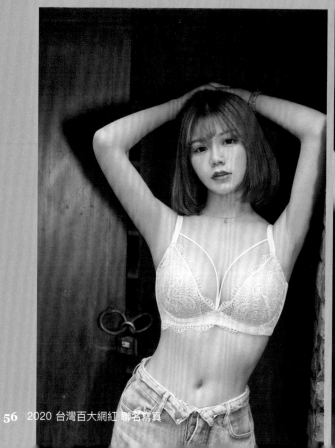
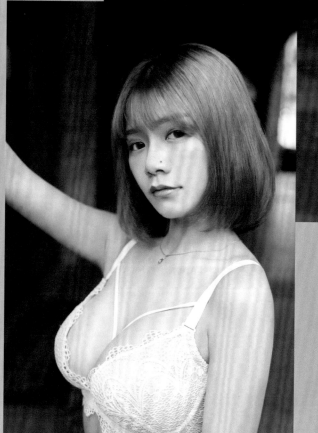

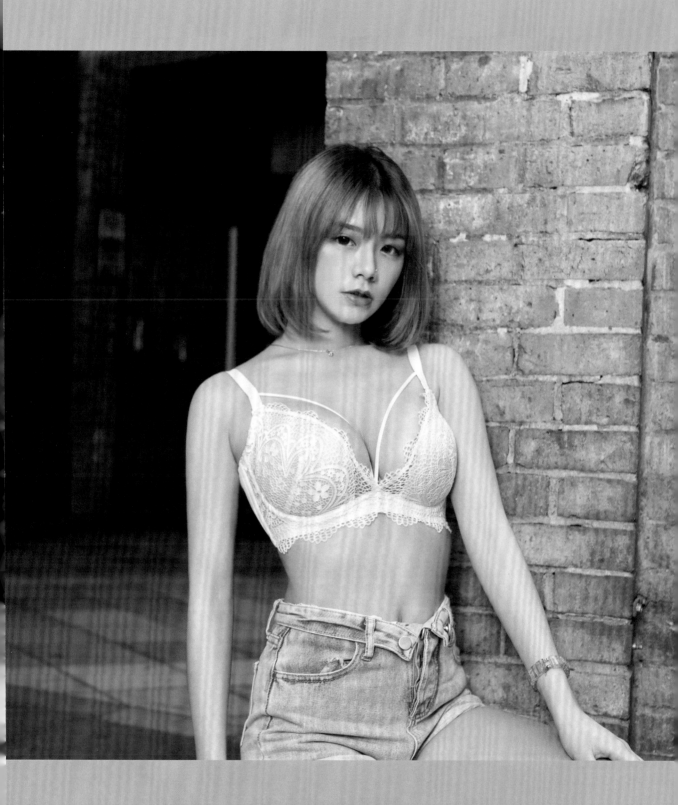

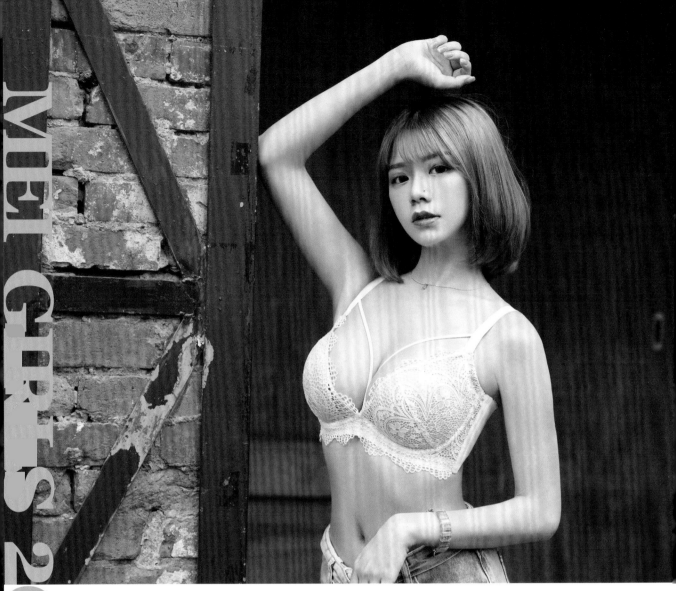

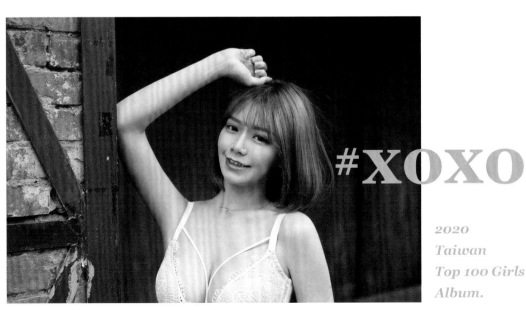

#XOXO

*2020
Taiwan
Top 100 Girls
Album.*

MEI GIRLS 2020

Summertime

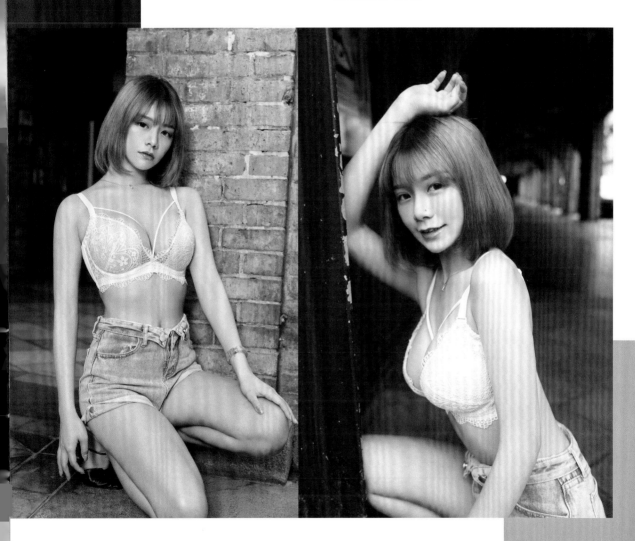

*Life Is Made Of
Small Moments
Like This*

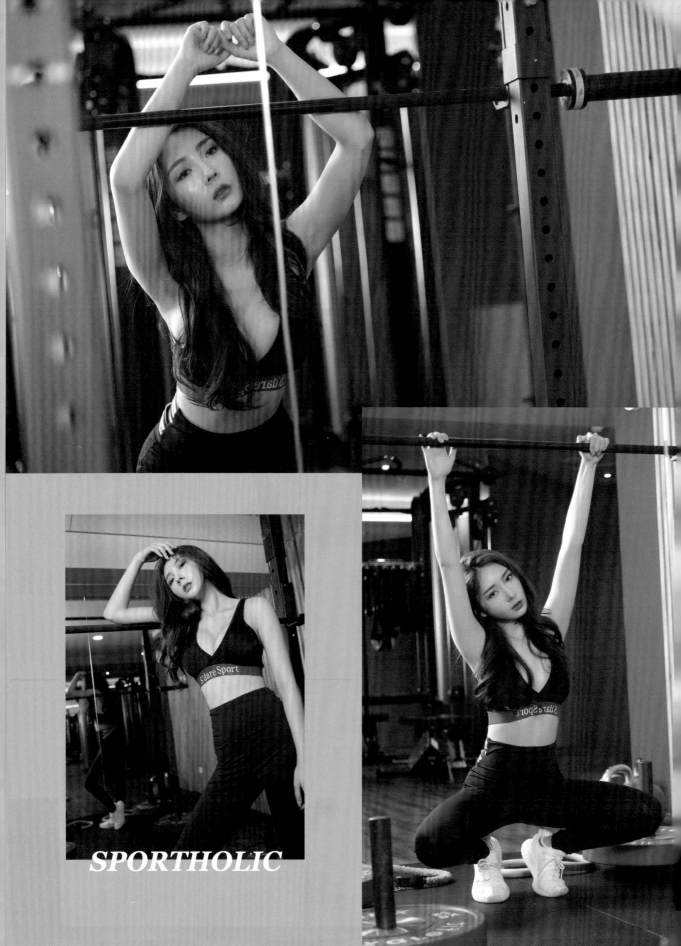

SPORTHOLIC

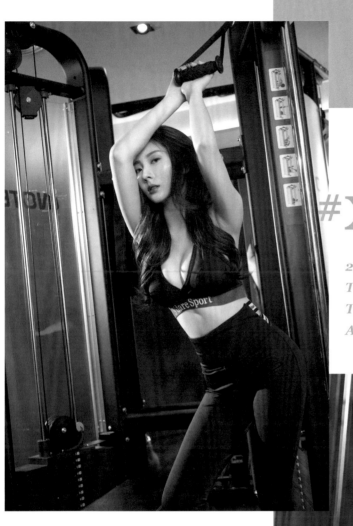

#XOXO

2020
Taiwan
Top 100 Girls
Album.

MEI GIRLS
2020

-

Dream
A Little Dream
Of Me

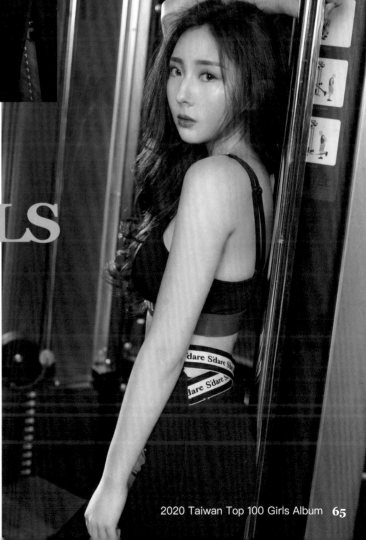

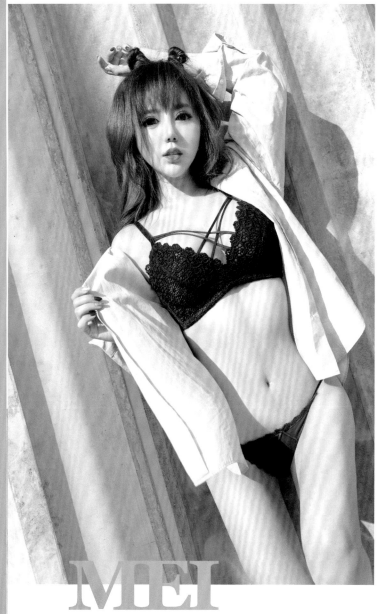

*You Are
My
Adventure*

**Closer to happiness
than I've ever been**

MEI
GIRLS
2020

**Taiwan Top 100 Girls
Album.**

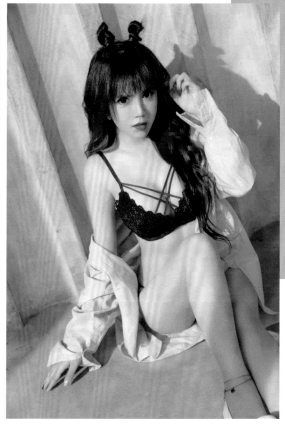

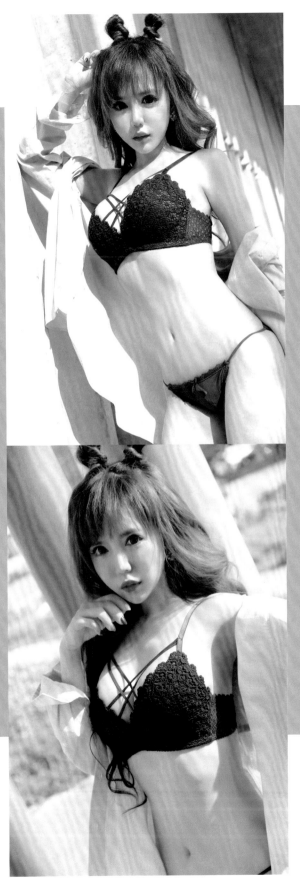

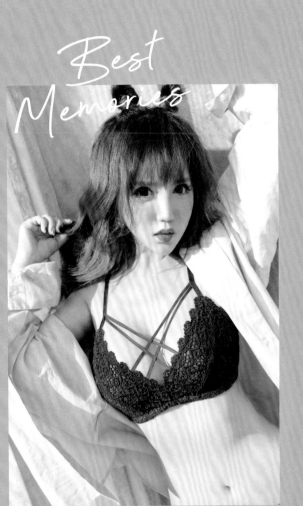

Best Memories

Shining Day

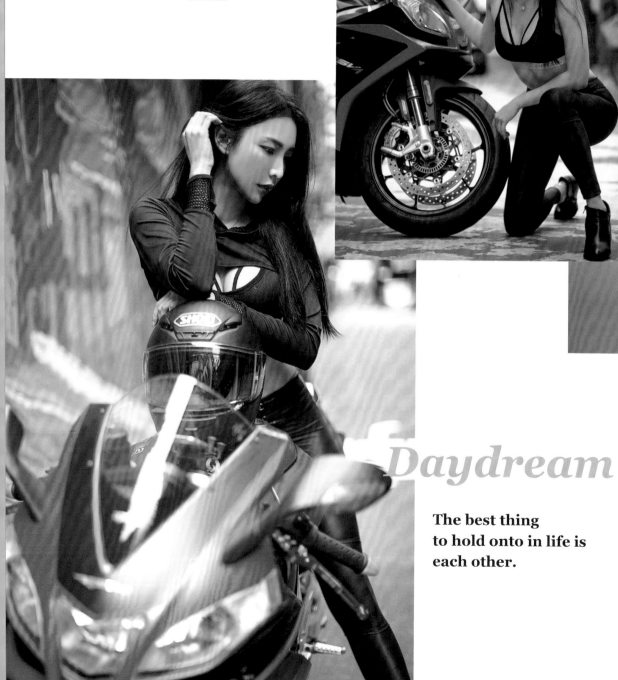

MEI GIRLS
2020

**Taiwan Top 100 Girls
Album.**

Daydream

**The best thing
to hold onto in life is
each other.**

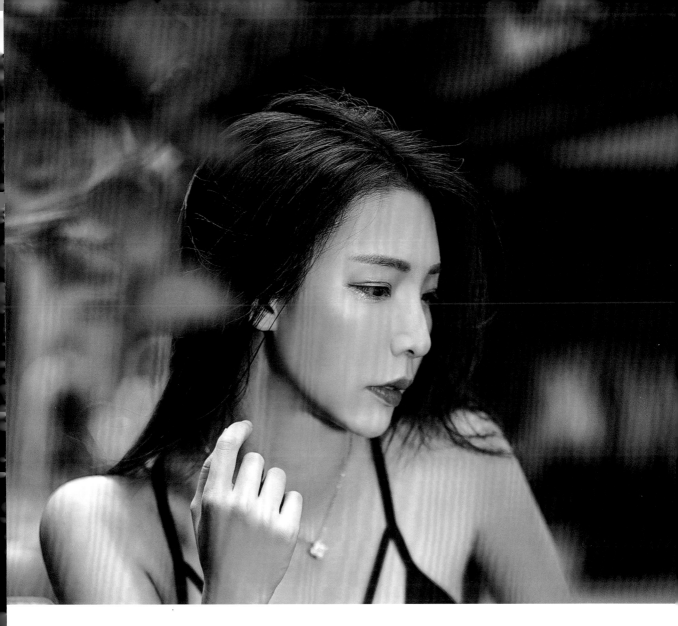

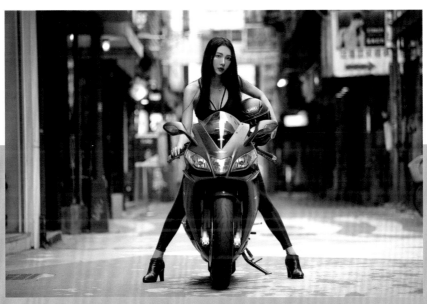

MEI GIRLS ✕ 2020

安琪

Angel

instagram : @anchi916

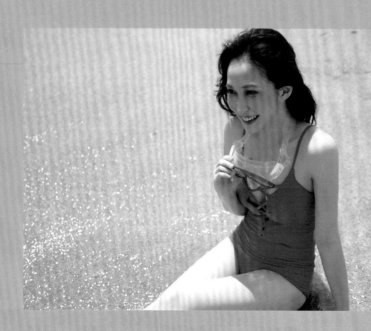

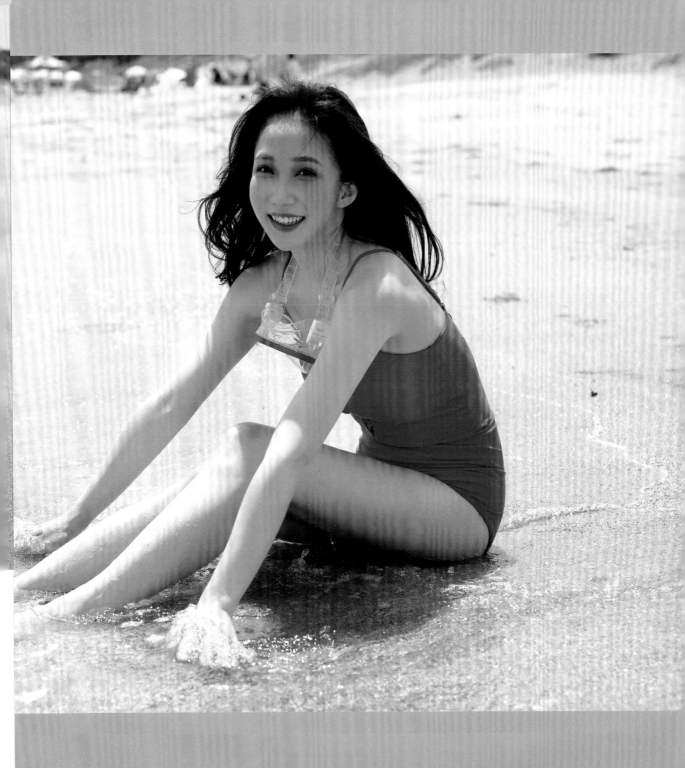

可愛只是兩個字，卻跟了我一生一世。

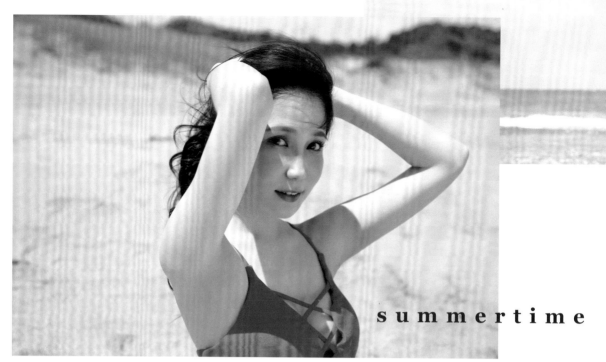

summertime

Breezy
Summer
Day

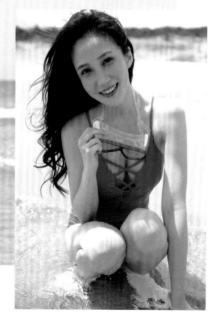

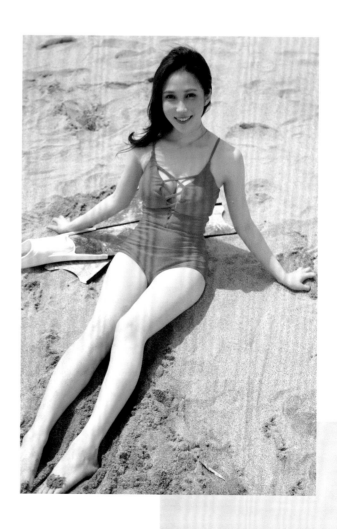

Dream
a little dream
of me

MEI
GIRLS
2020
Angel

Taiwan Top 100 Girls Album.

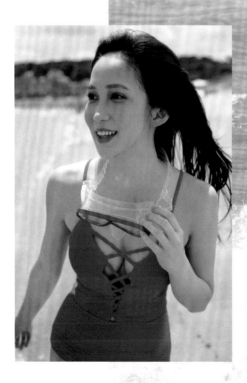

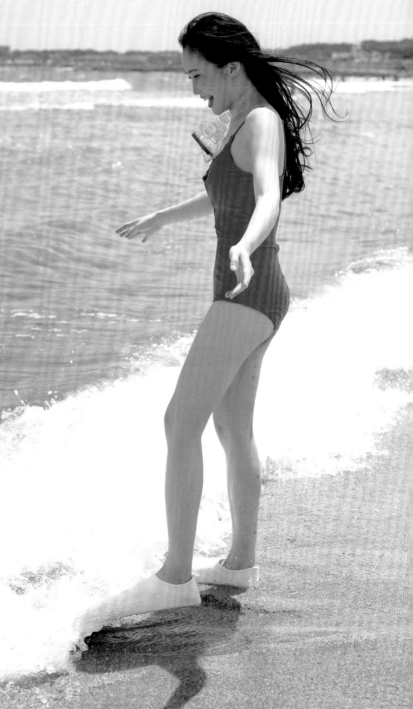

s u m m e r t i m e

MEI
GIRLS
✕
2020

潔西

Jessie

📷 instagram : @sheep_tsai

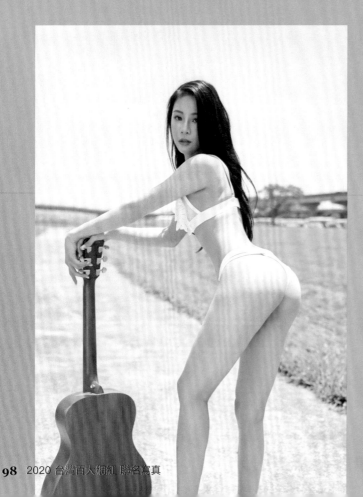

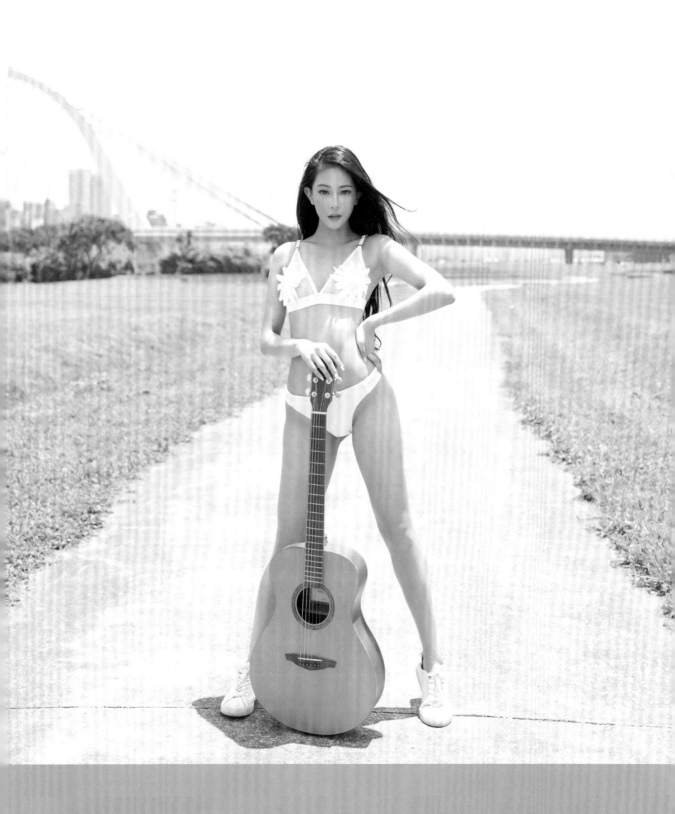

別的女孩都迷人，
我不一樣，我磨人。

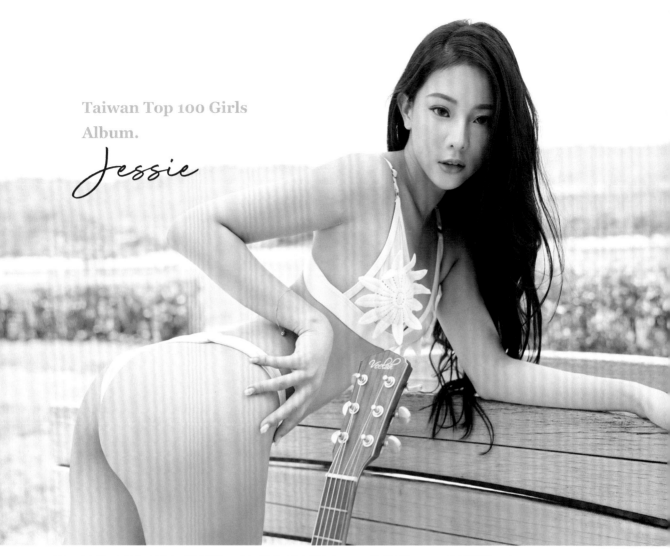

Taiwan Top 100 Girls
Album.
Jessie

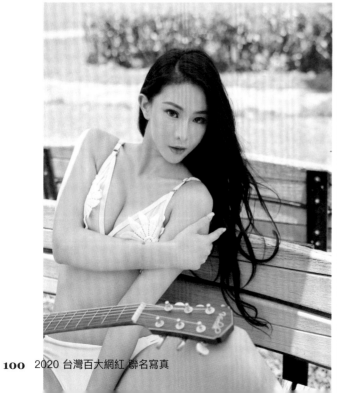

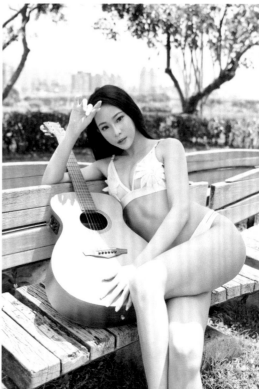

MEI GIRLS
2020
Jessie

Summer
Vibes

-

In your life
my infinite dreams live.

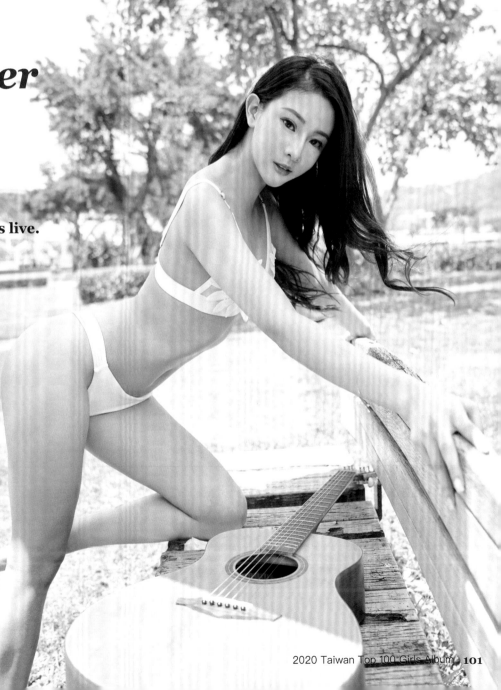

All Of Me
Loves
All Of You

Dream
a little dream
of me

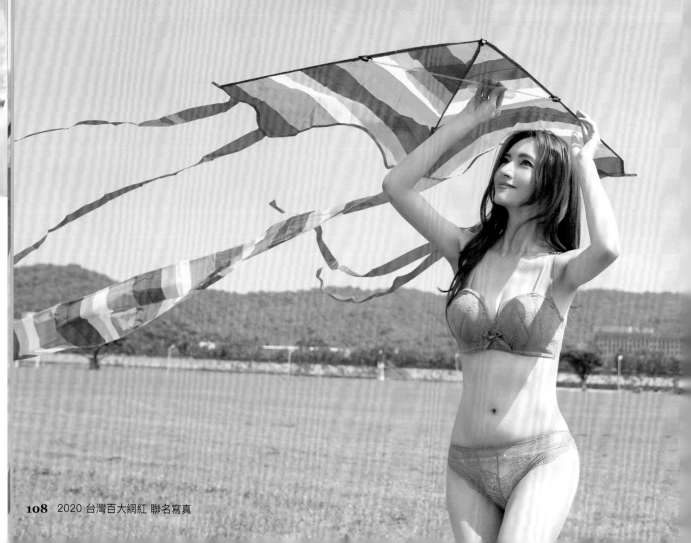

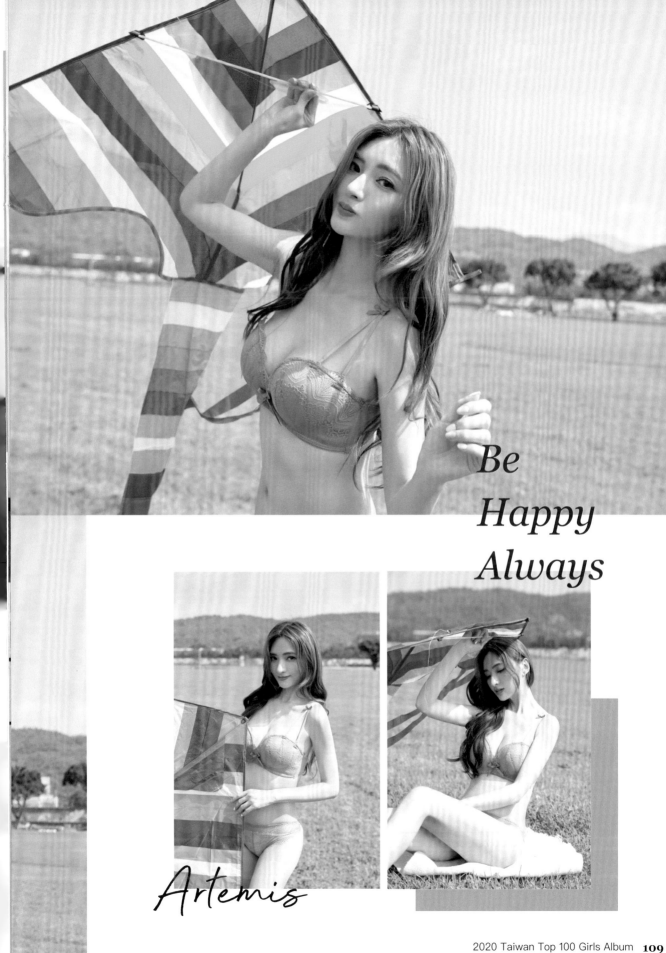

Be
Happy
Always

Artemis

MEI
GIRLS
✕
2020

子珊

Freya

📷 instagram : @tzushan520_

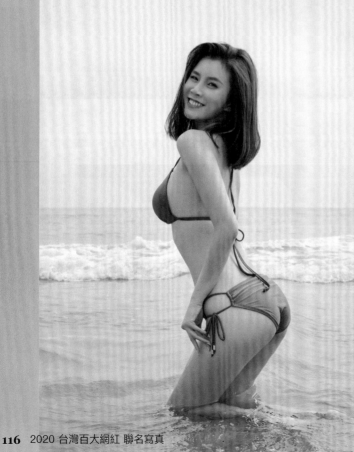

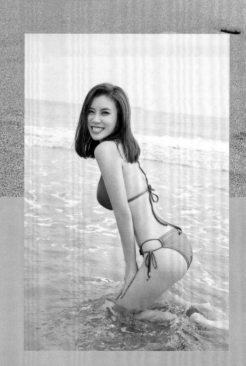

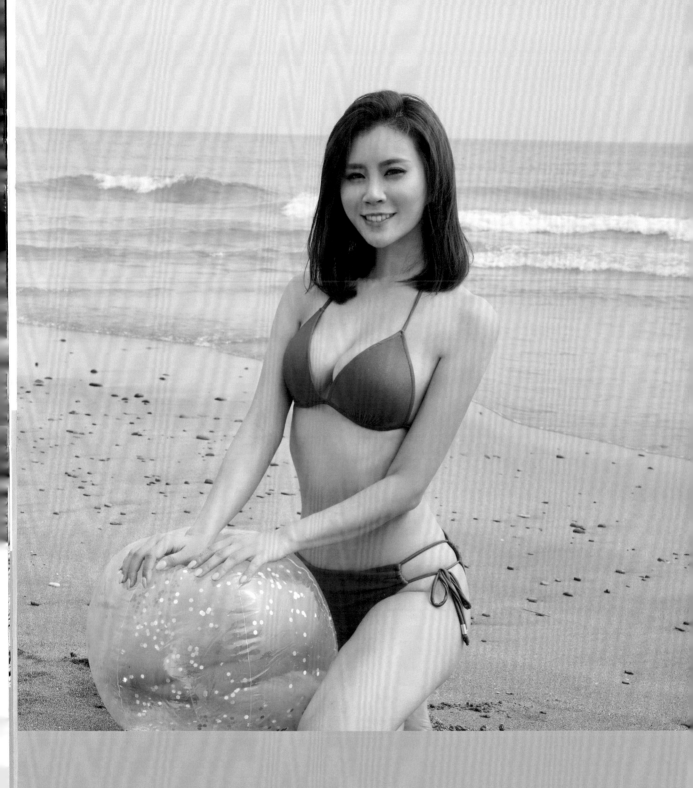

好好生活，慢慢愛你，
不早不晚，剛好是你。

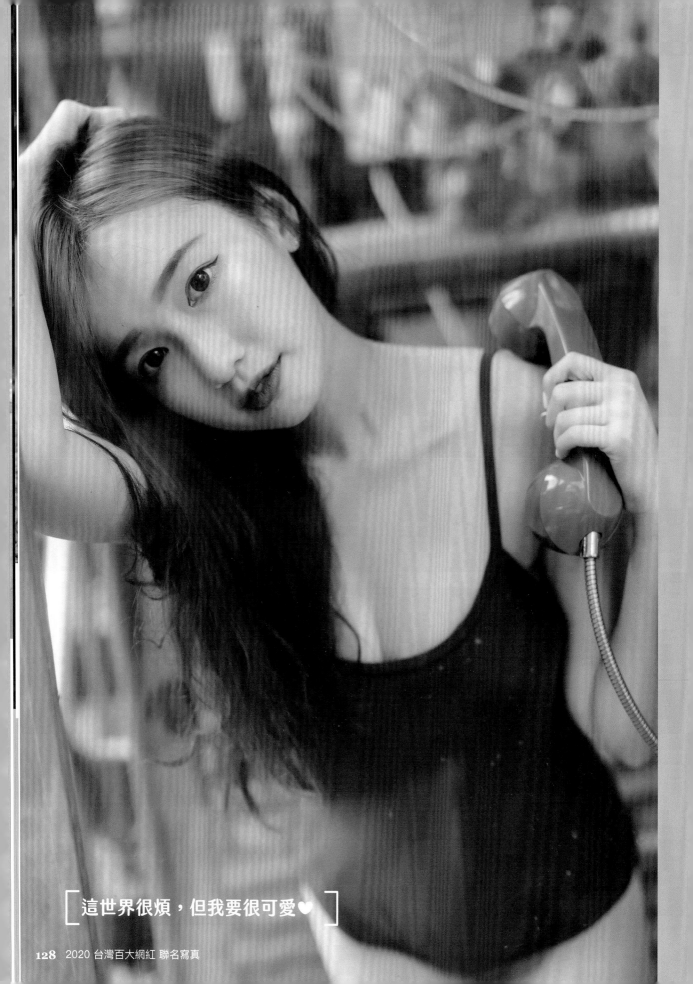

這世界很煩，但我要很可愛❤

MEI GIRLS
✕
2020

柯姿
Kzi

📷 instagram : @kziiee

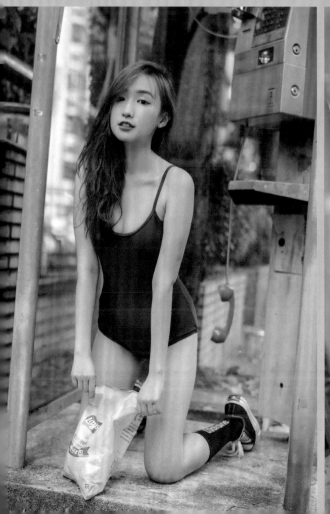

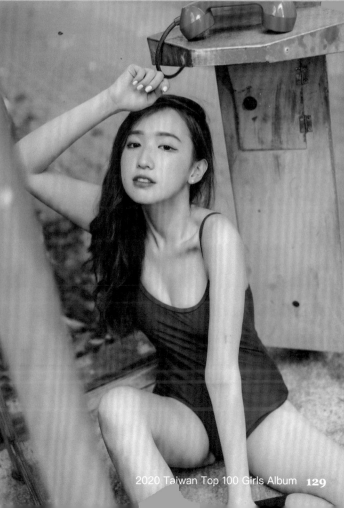

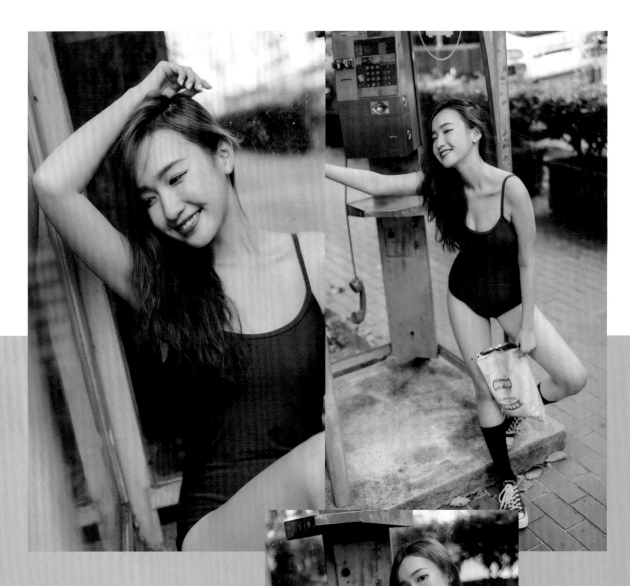

MEI
GIRLS
✕
2020

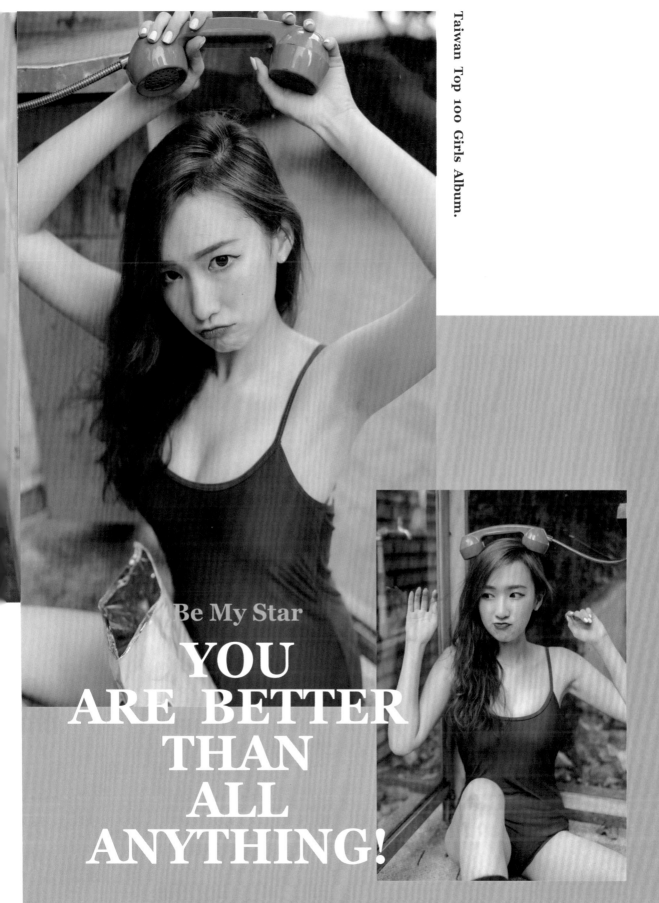

Be My Star

YOU ARE BETTER THAN ALL ANYTHING!

MEI GIRLS ✕ 2020

Salen

:camera: instagram : @salen_wu

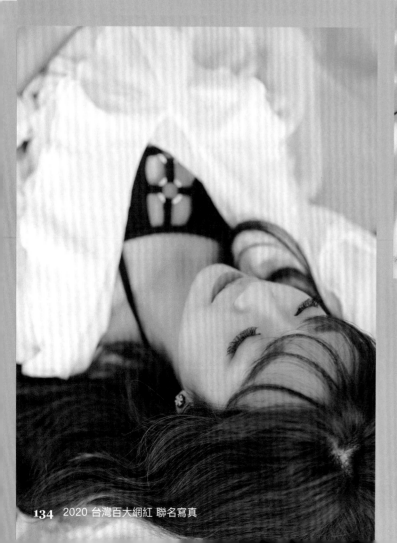

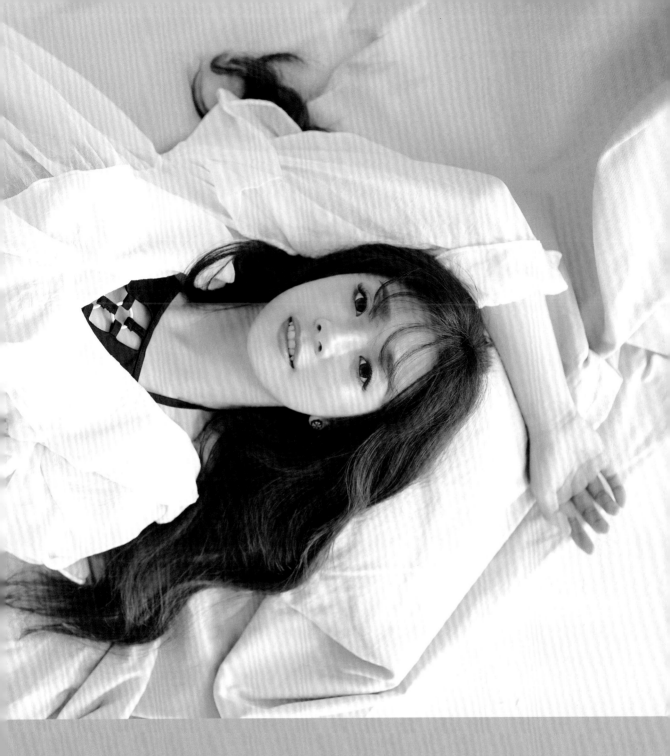

不用再問我都飛什麼線，
因為我飛的都叫理智線。

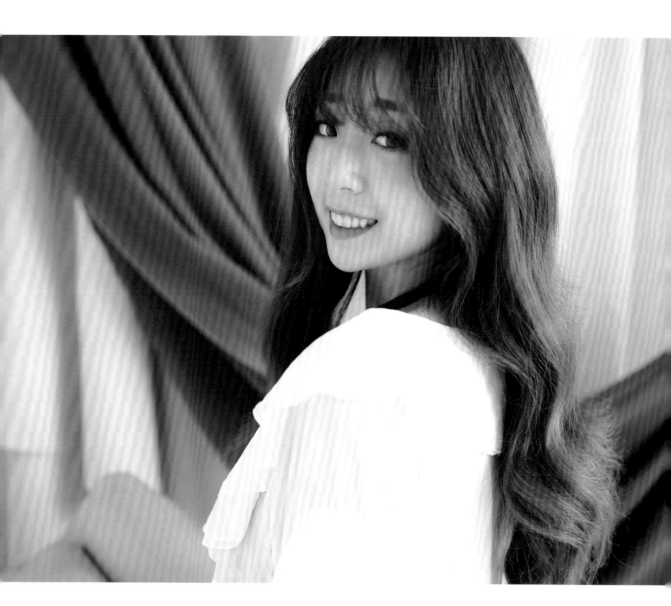

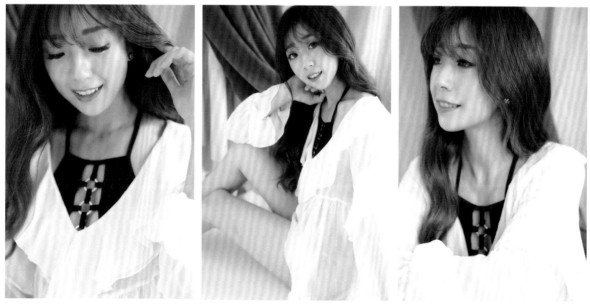

Taiwan Top 100 Girls Album.

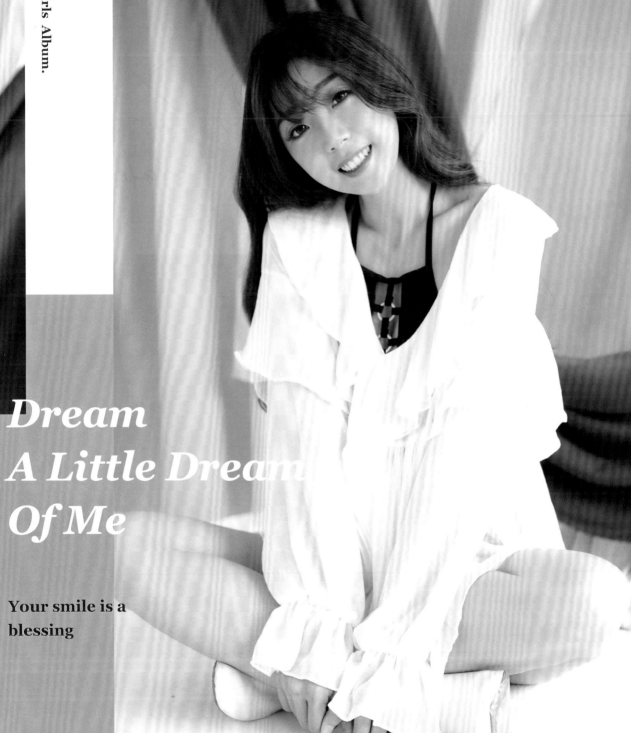

Dream
A Little Dream
Of Me

**Your smile is a
blessing**

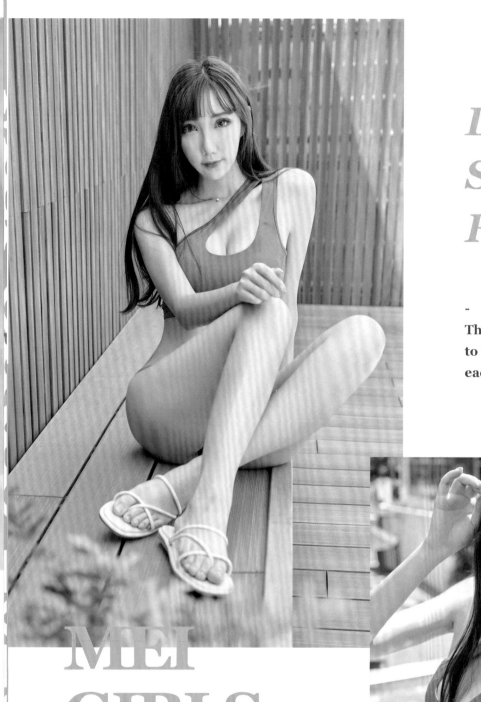

*Let Me
Shine
For You*

-

**The best thing
to hold onto in life is
each other.**

MEI
GIRLS
2020 *Juby*

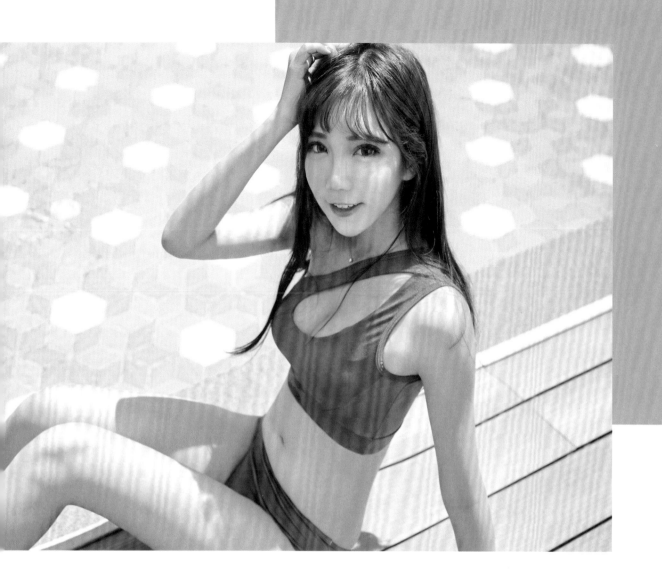

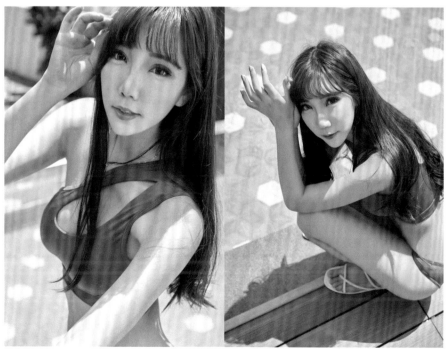

MEI
GIRLS

2020

小筑
Nina

instagram : @changyachuu

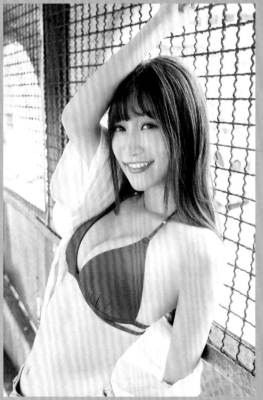

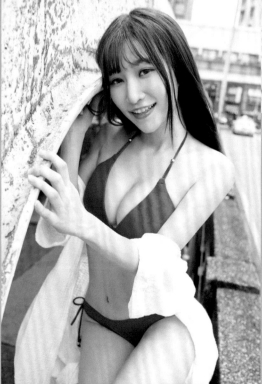

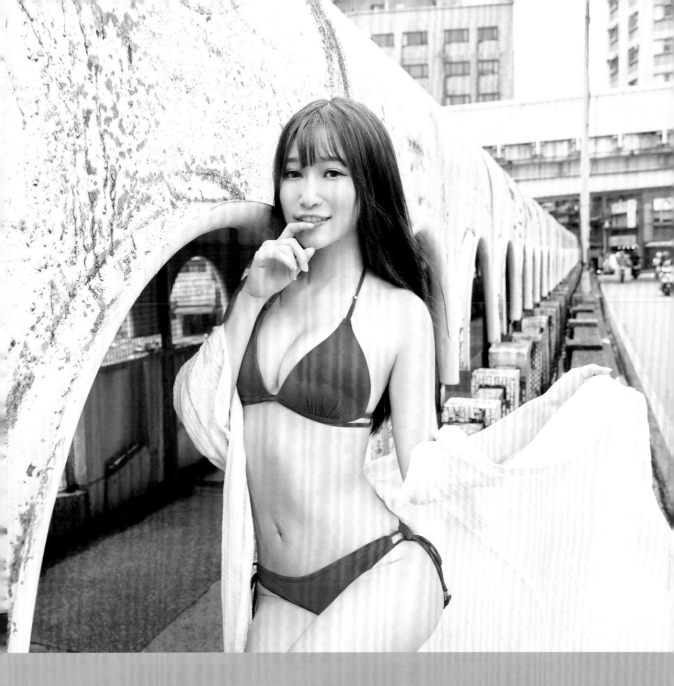

最近心不在焉，因為心在你那邊♥

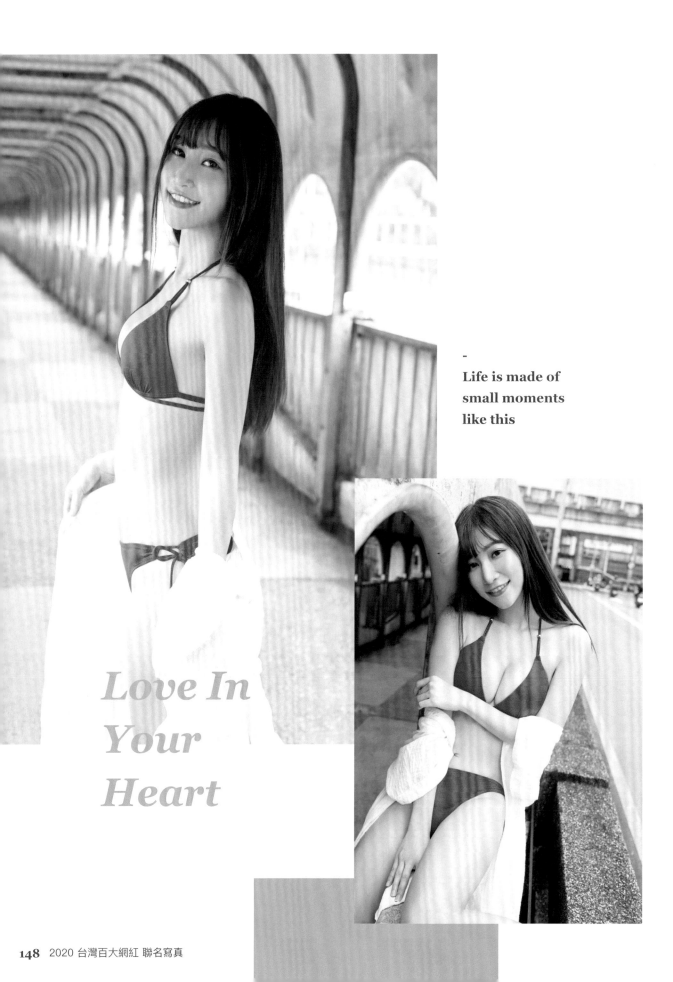

-
**Life is made of
small moments
like this**

*Love In
Your
Heart*

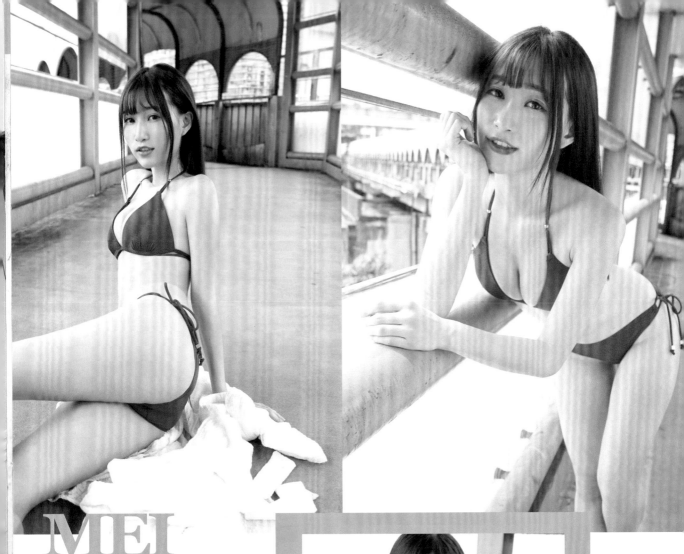

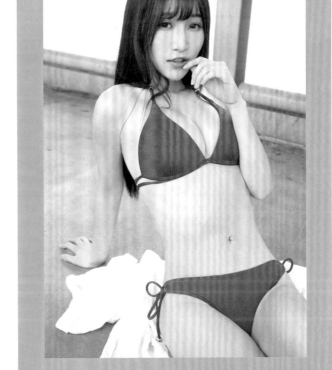

MEI
GIRLS
2020
Nina

Taiwan
Top 100 Girls Album.

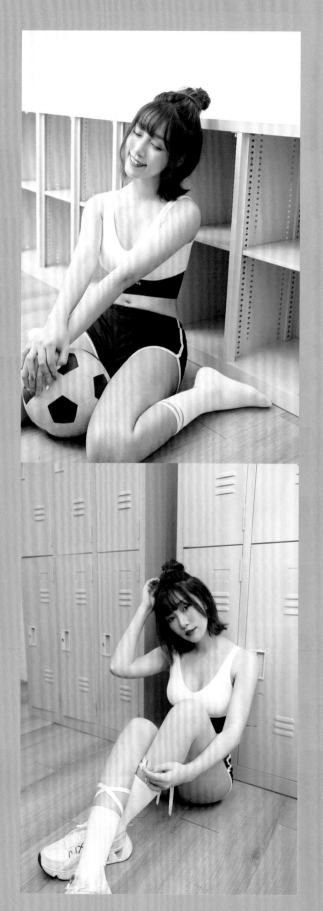

Be Happy Always

-

**Wish some days
lasted forever**

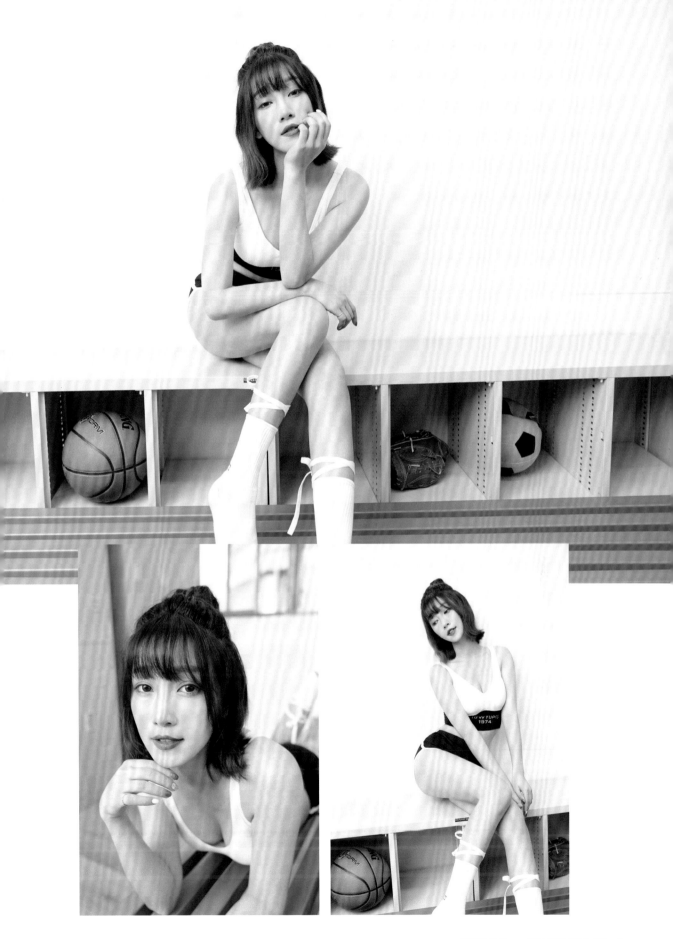

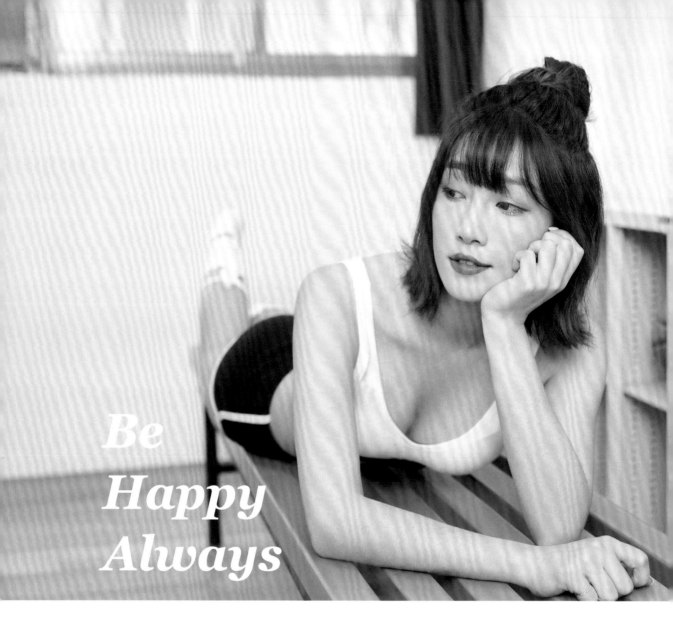

Be
Happy
Always

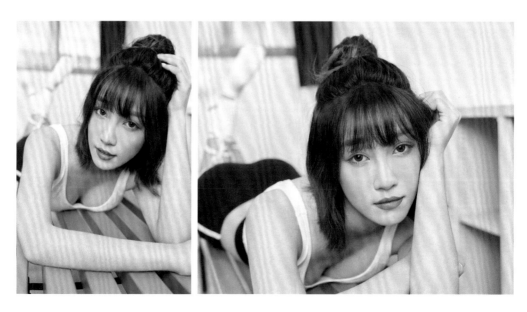

MEI GIRLS

✕

2020

-

**Wish some days
lasted forever**

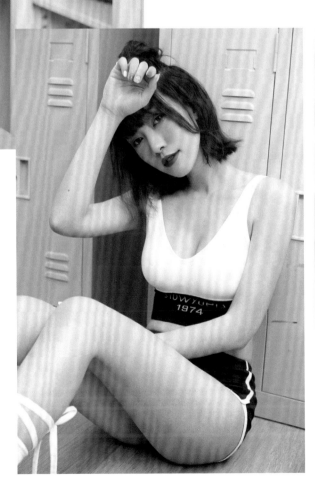

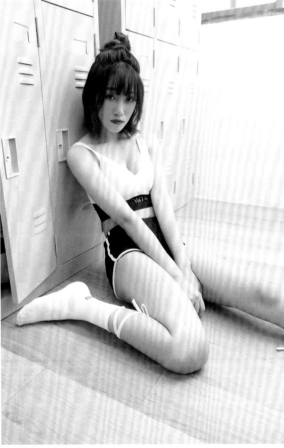

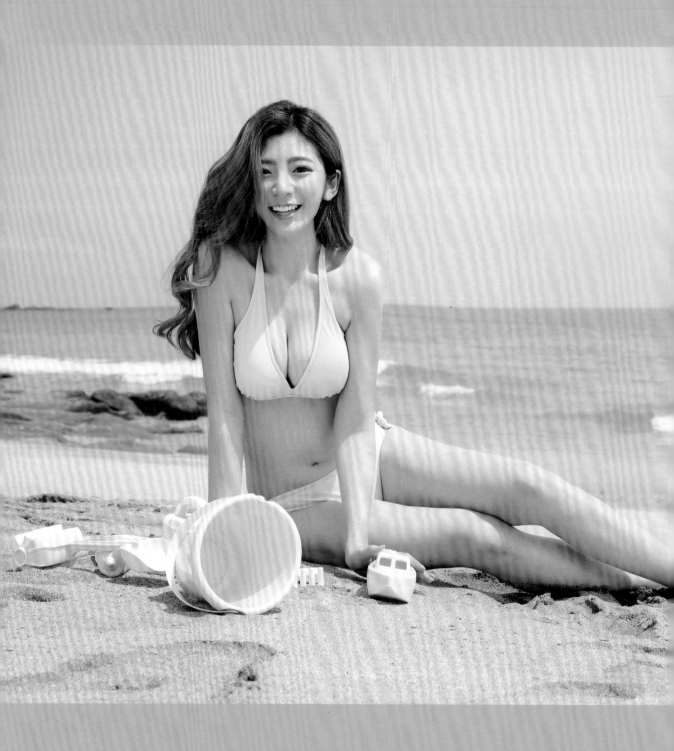

生命中的不期而遇
都是你努力的驚喜♥
-
Unexpected encounters in life
are all surprises in your efforts ♥

MEI
GIRLS
✕
2020

咪雅

Mia

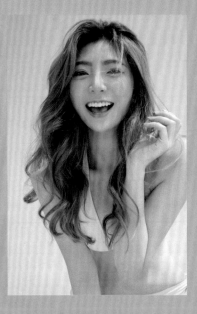 instagram : @mia2609842

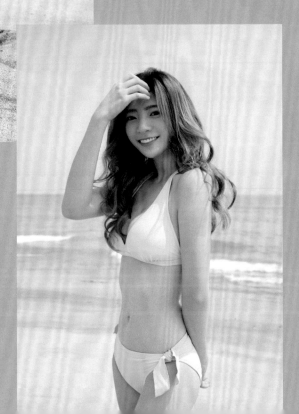

MEI GIRLS
✕
2020

尤尤
Linda

📷 instagram : @linda.zz99tw

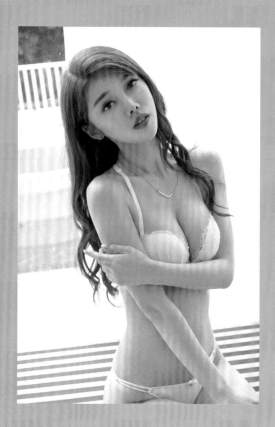

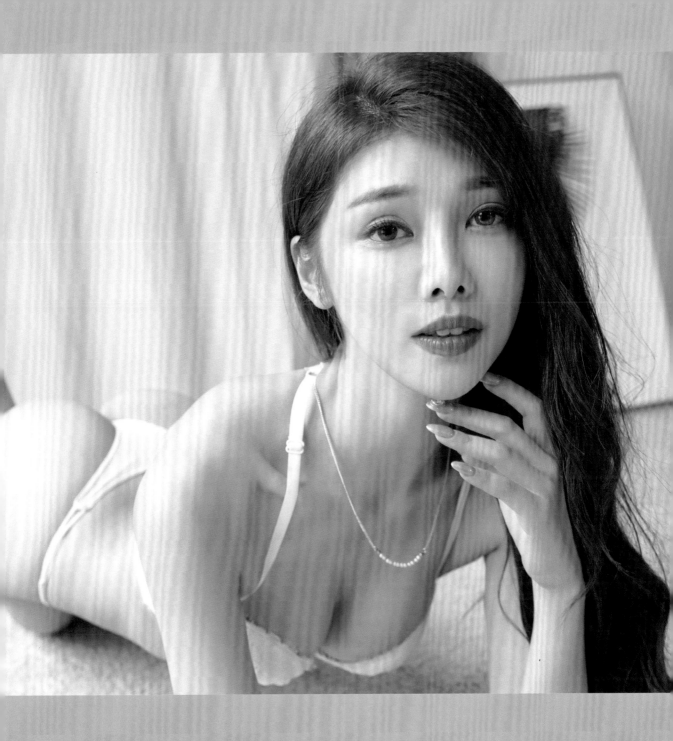

千辛萬苦，只為與你修成正果 ♥

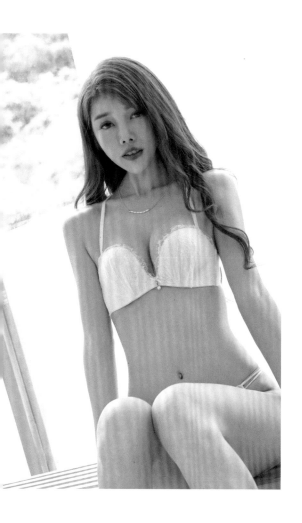

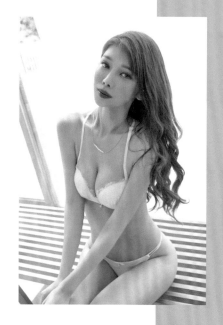

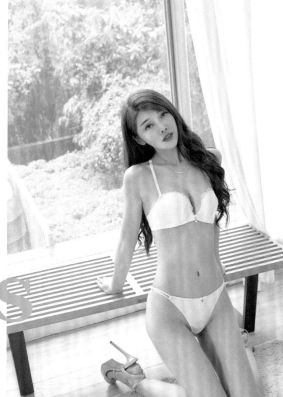

MEI GIRLS
2020
Linda

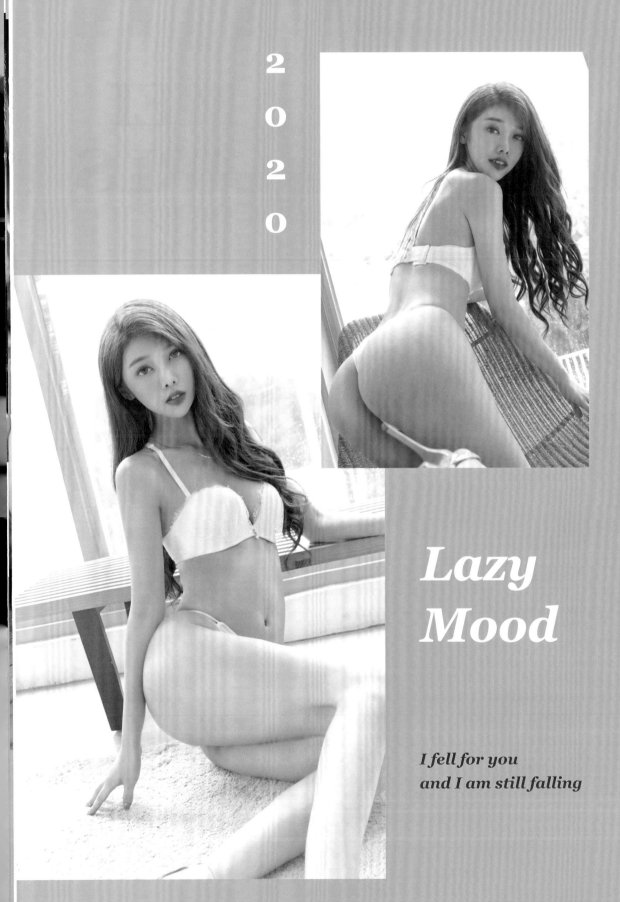

2 0 2 0

Lazy Mood

*I fell for you
and I am still falling*

MEI
GIRLS
✕
2020

肝連
Miao

📷 instagram : @miaoo131

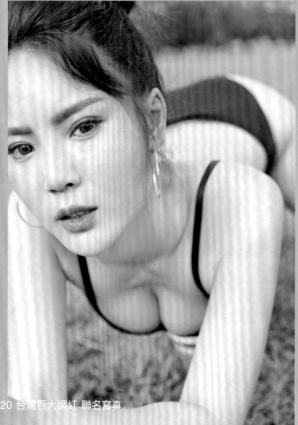

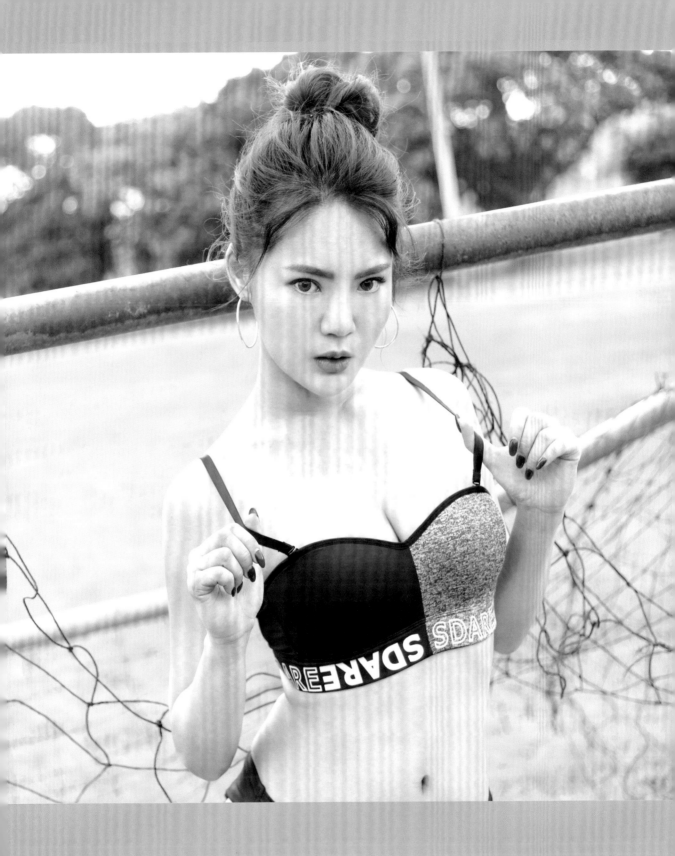

月亮不睡我不睡，我是你的小寶貝。

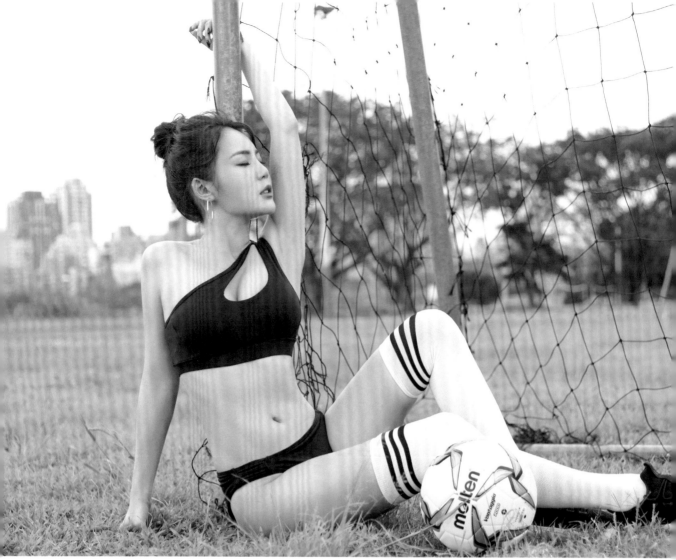

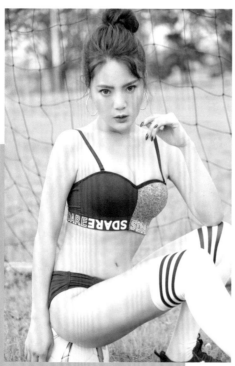

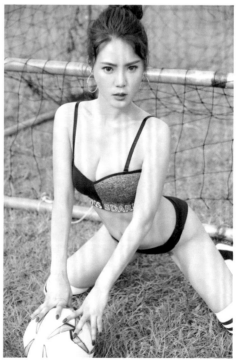

Sporty
Girl

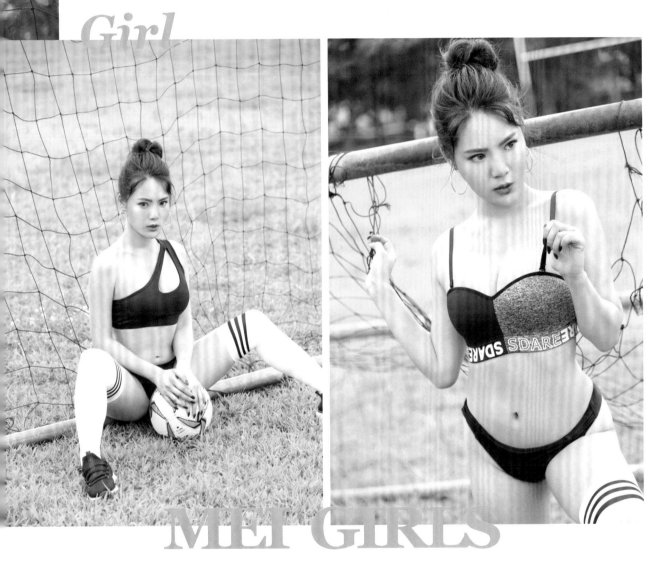

MEI GIRLS
2020
Miao

Summer Breeze

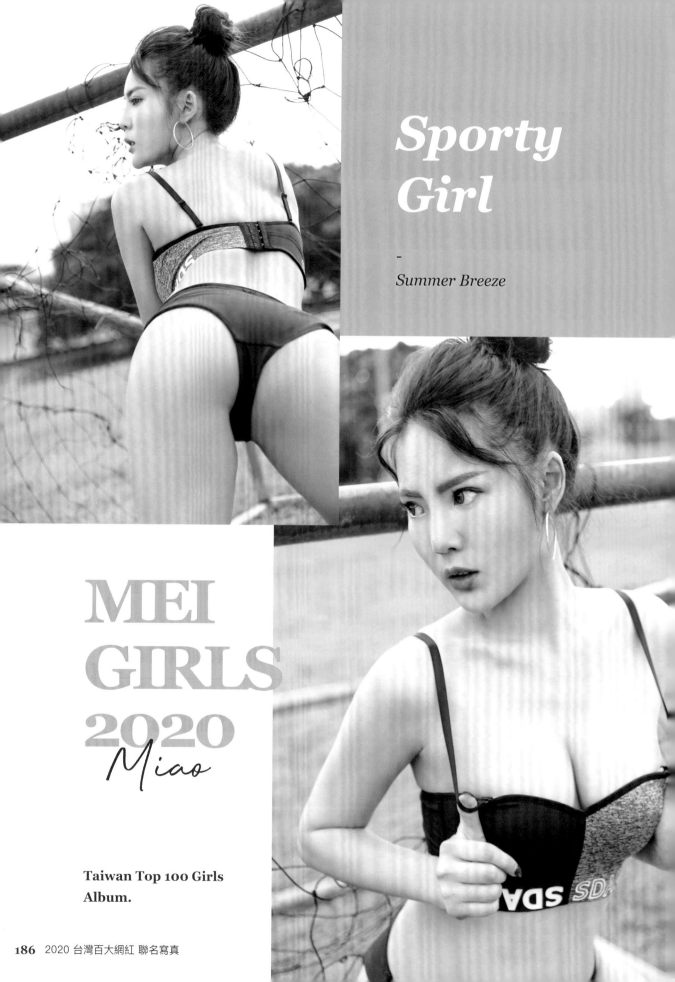

Sporty Girl

-

Summer Breeze

MEI GIRLS 2020 *Miao*

Taiwan Top 100 Girls Album.

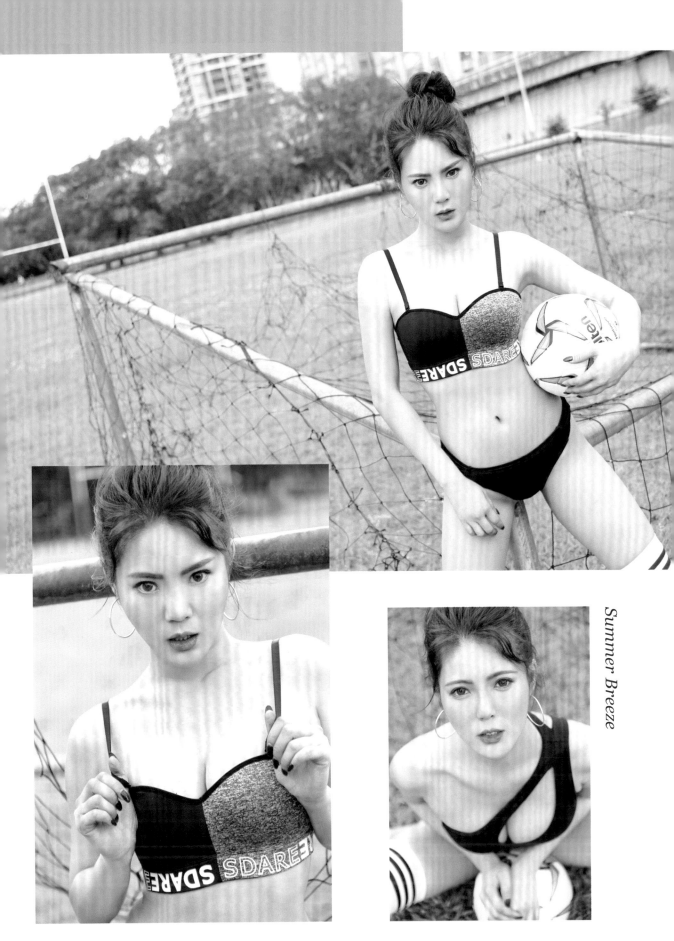

Summer Breeze

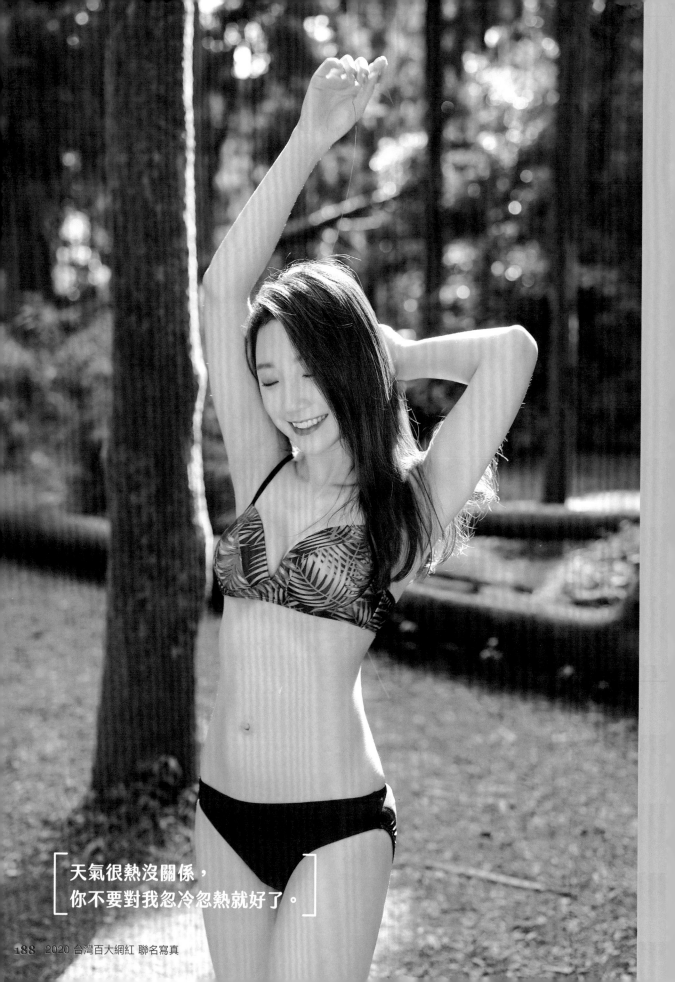

天氣很熱沒關係，
你不要對我忽冷忽熱就好了。

MEI
GIRLS
✕
2020

木子萱

 instagram：@mz1219

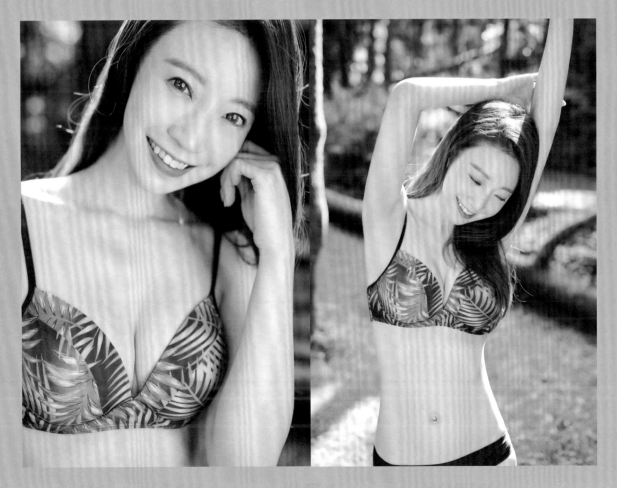

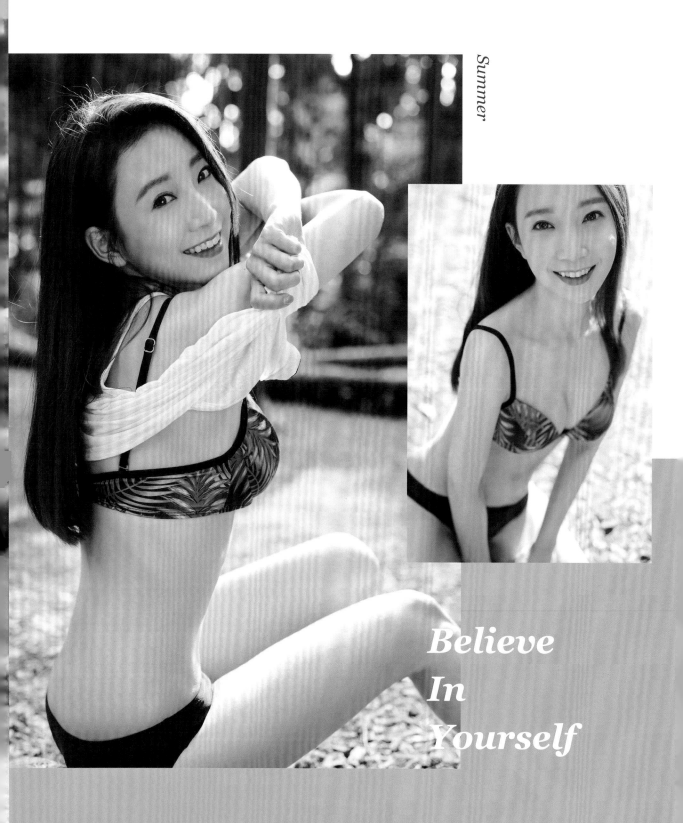

Summer

Believe
In
Yourself

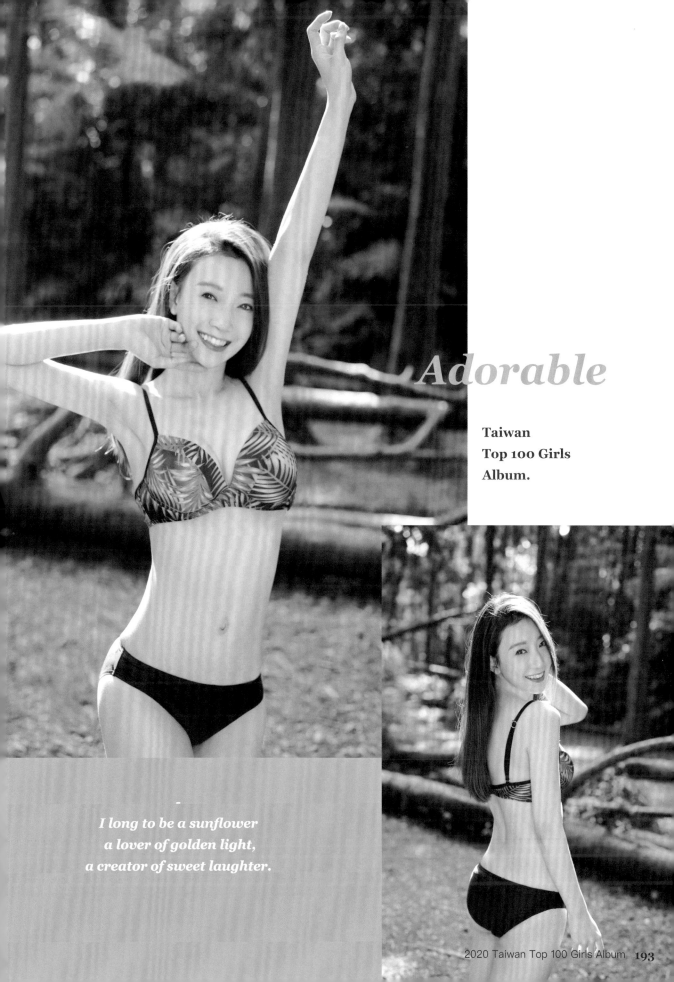

Adorable

Taiwan
Top 100 Girls
Album.

-

I long to be a sunflower
a lover of golden light,
a creator of sweet laughter.

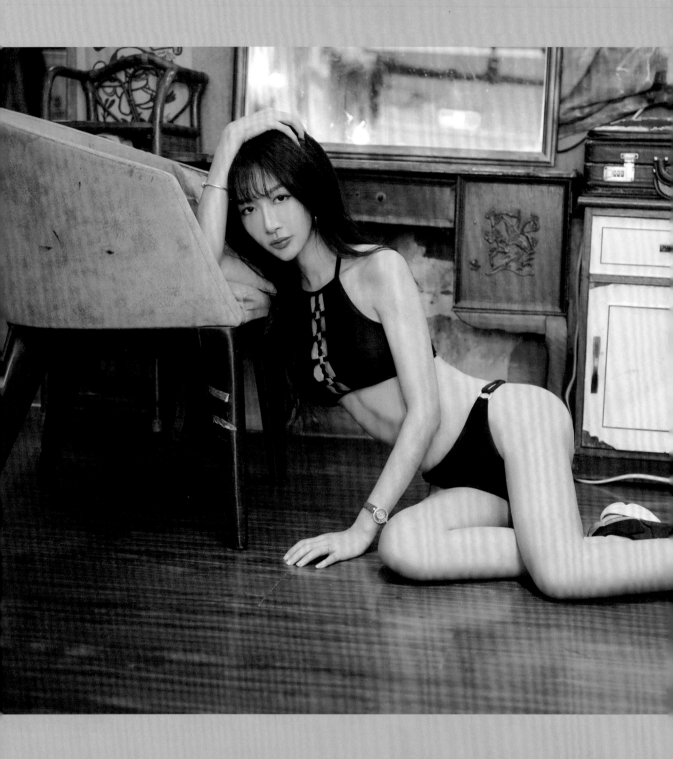

2020 年 YouTube 頻道，
努力邁入 20 萬訂閱！

MEI
GIRLS
✕
2020

釣蝦女神系
沐雨柔

📷 instagram：@evemu716

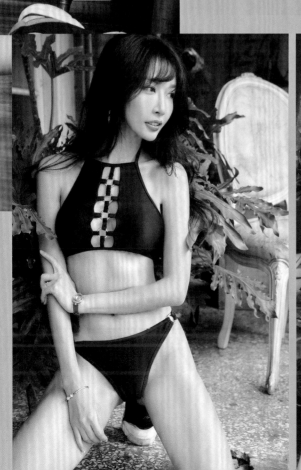

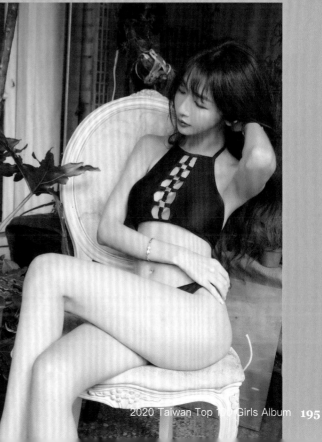

Make
Dream
Come True

-

*I fell for you and I am
still falling, you are my
new favorite feeling.*

MEI GIRLS
2020

2020
Taiwan
Top 100 Girls Album

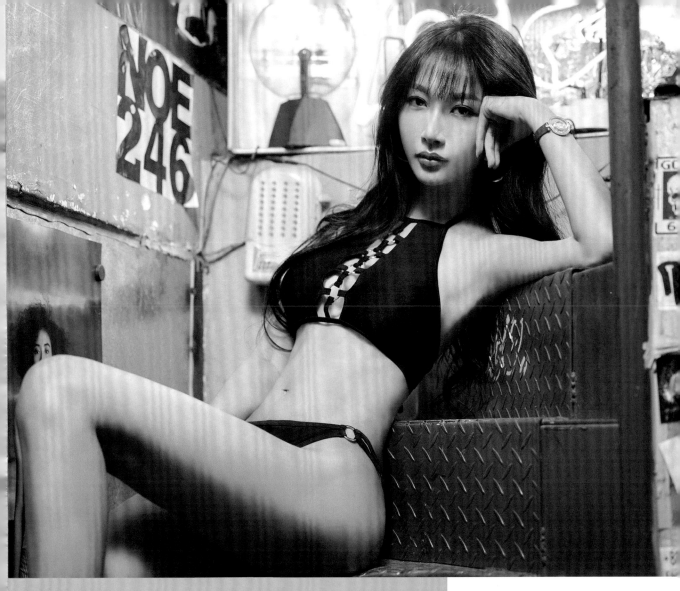

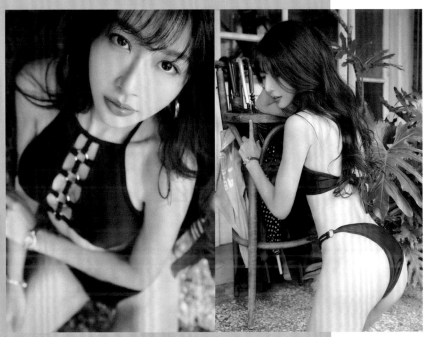

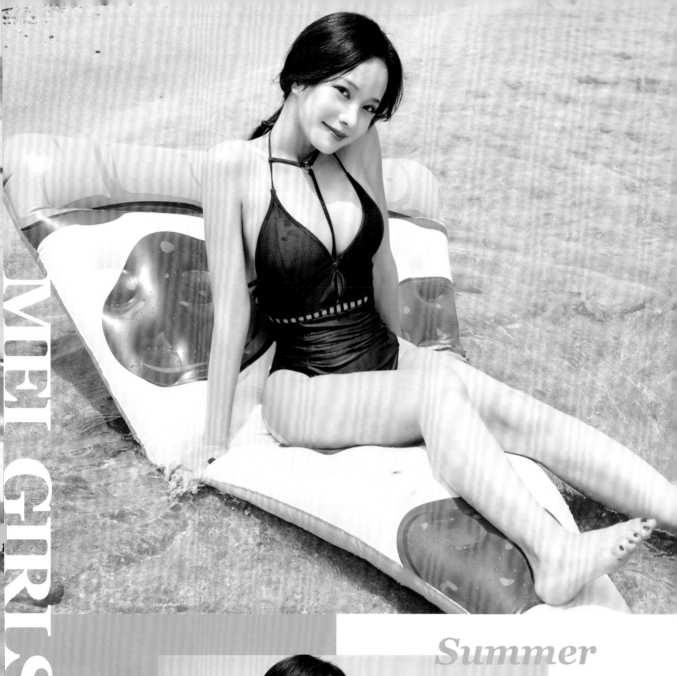

MEI GIRLS 2020

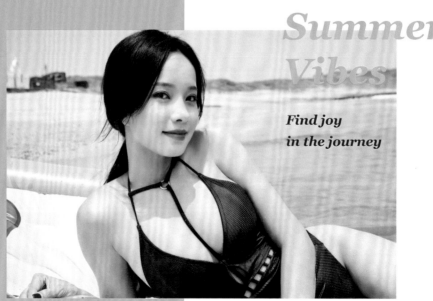

Summer
Vibes

Find joy
in the journey

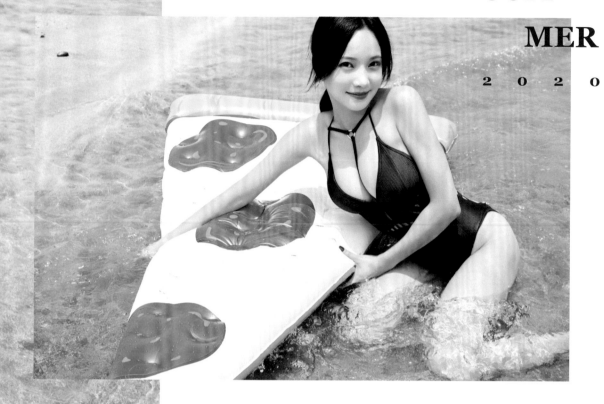

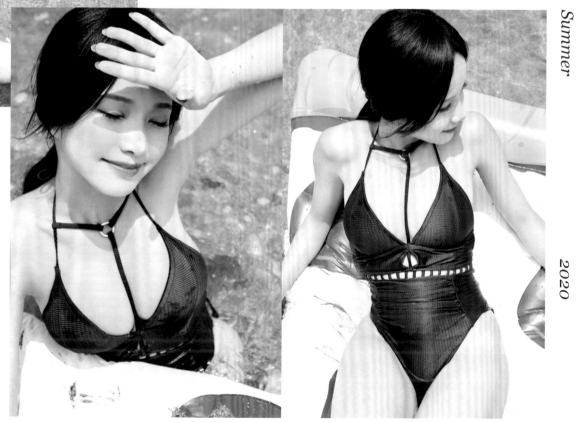

MEI
GIRLS
×
2020

吳芸帆

Micky

instagram：@mickybaby0611

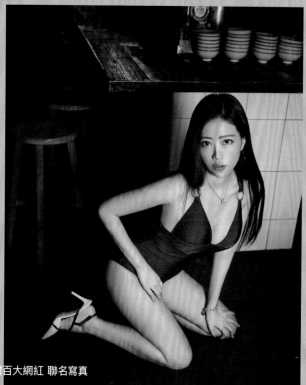

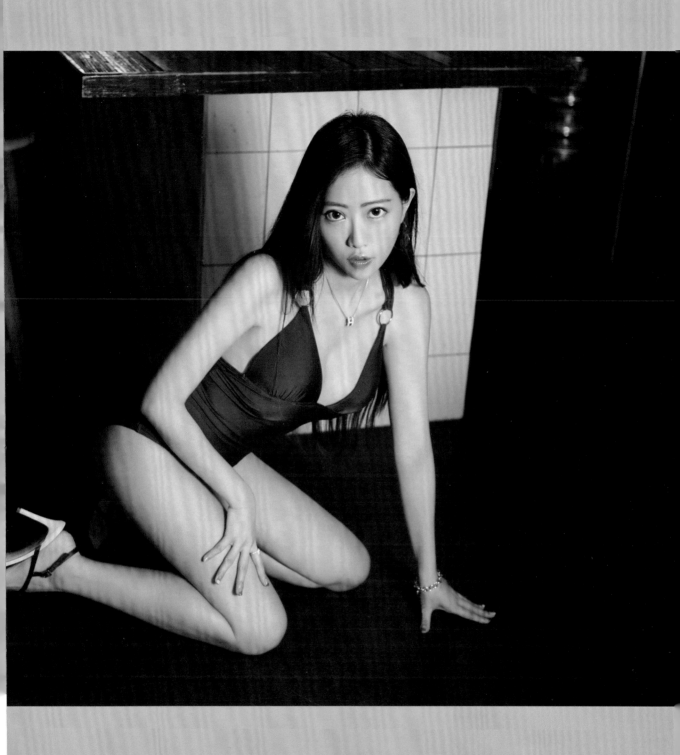

現在認識還不算晚，就怕你不來認識我。

Make
Today
Magical

-

I'm happy
when
I'm with you

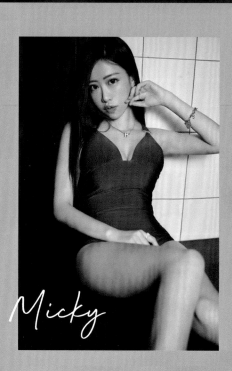

Micky

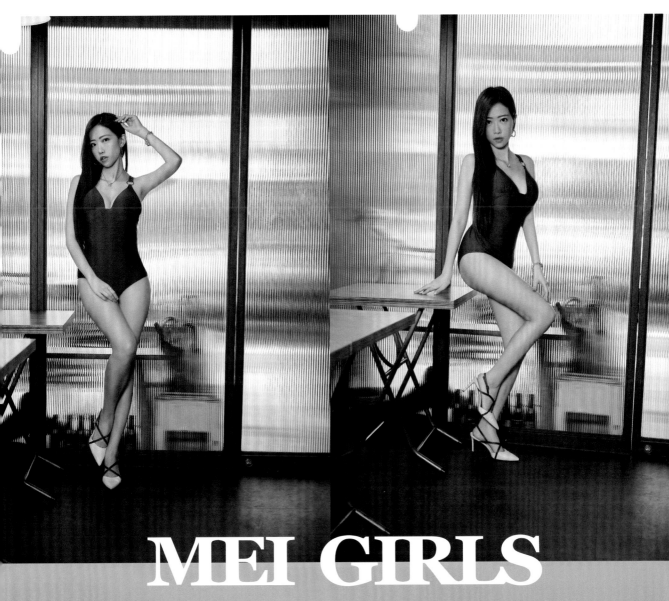

MEI GIRLS
2020
Micky

I'm happy
when I'm with you.

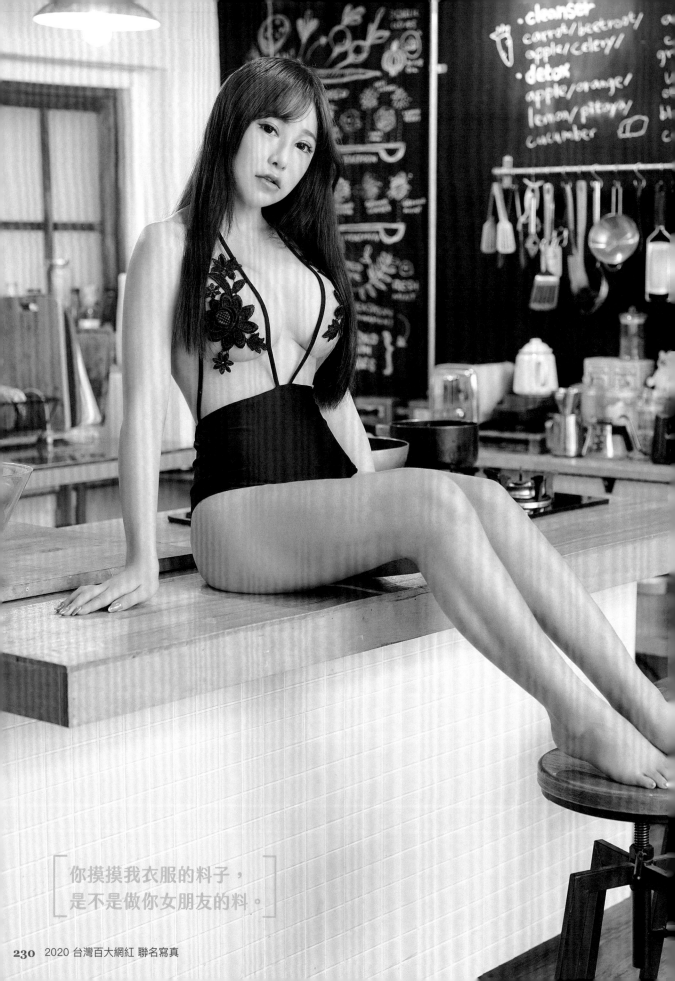

你摸摸我衣服的料子，
是不是做你女朋友的料。

MEI
GIRLS
✕
2020

詩錡
Vicky

📷 instagram：@11.xox.20

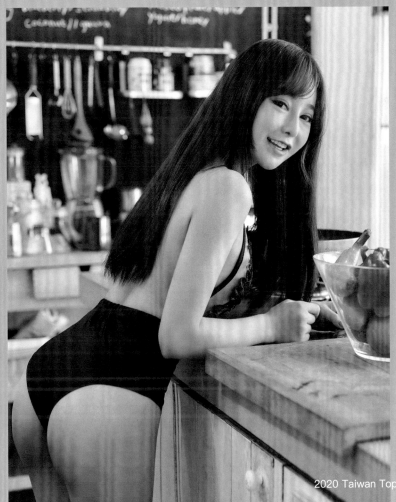

MEI
GIRLS

✕

2020

妮

Ginny

📷 instagram : @ginny1213

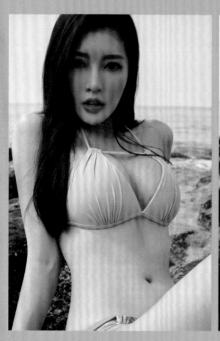
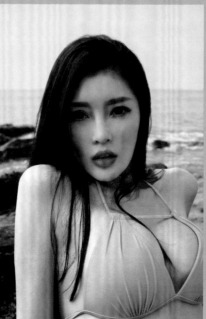
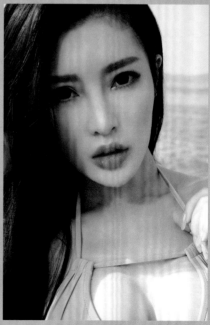

[愛笑愛鬧，任性也撒嬌♥]

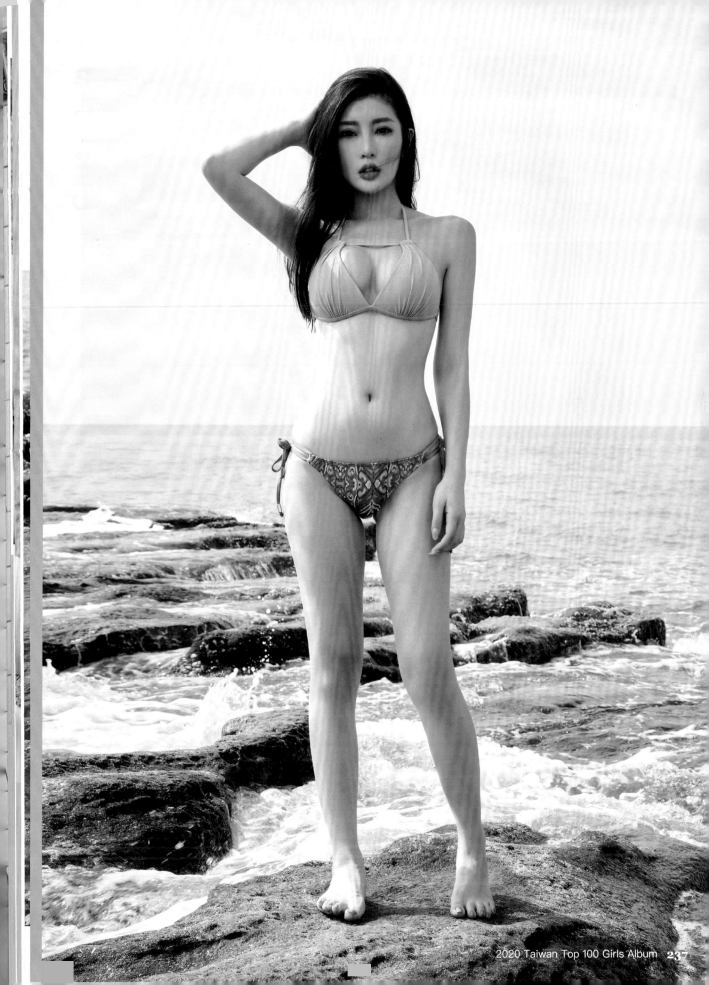

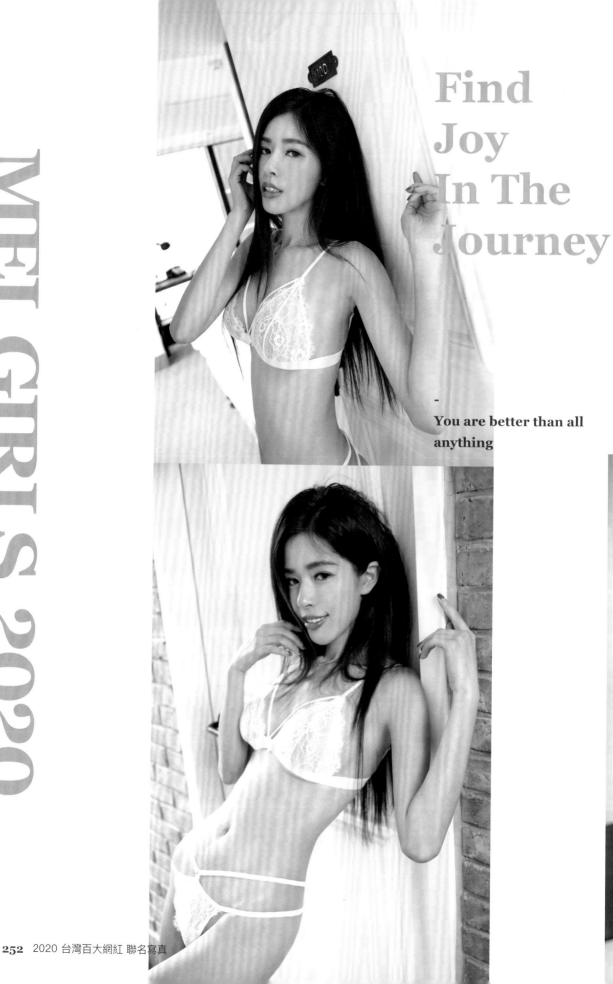

Find
Joy
In The
Journey

-

You are better than all anything

MEI GIRLS 2020

MEI
GIRLS
✕
2020

焦焦

Jiao

📷 instagram：@jiao_fff

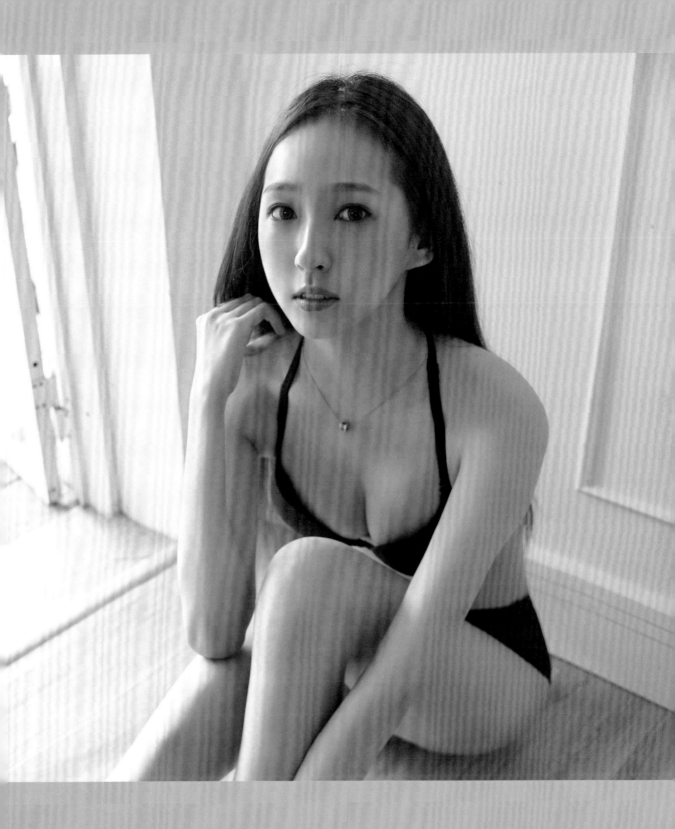

你追不到我，就追我 IG ♥

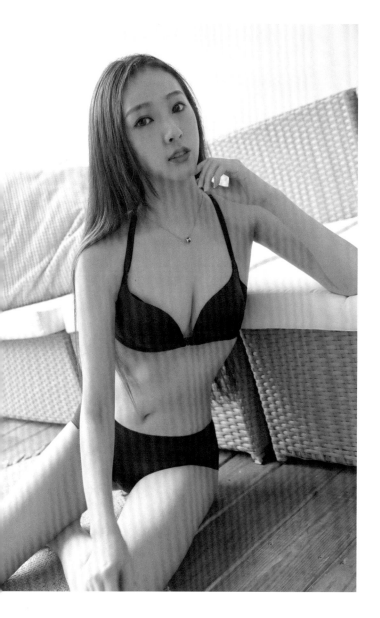

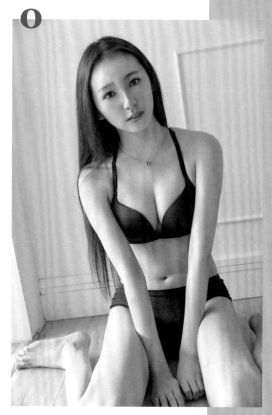

MEI
GIRLS
2020
Jiao

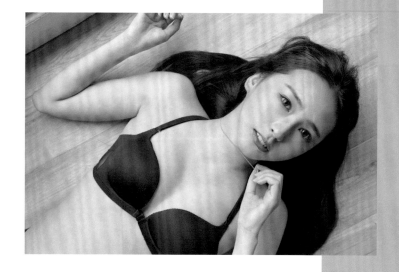

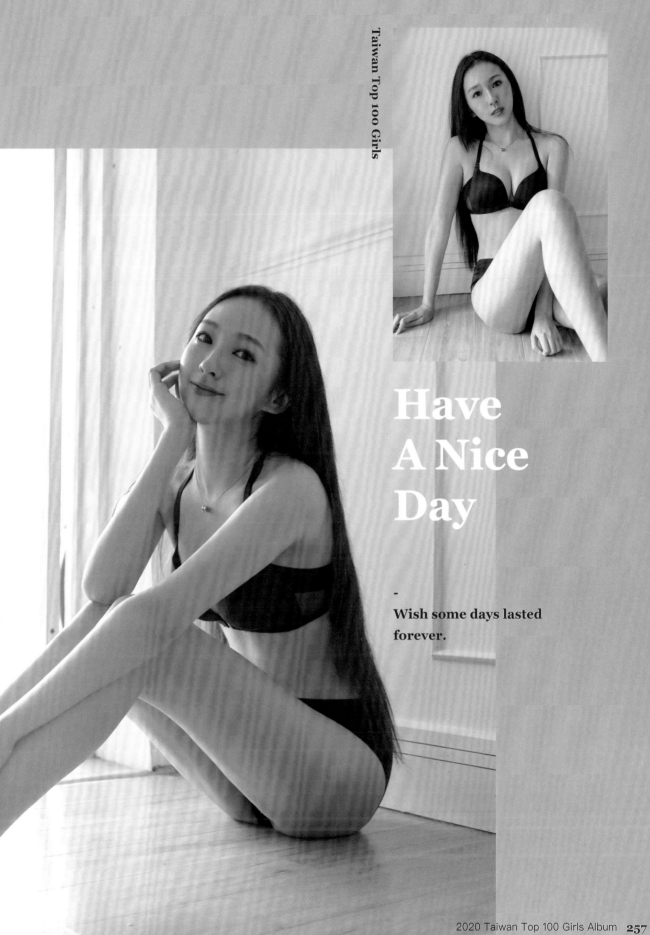

Have A Nice Day

-

**Wish some days lasted
forever.**

Have
A Nice
Day

-

**Wish some days lasted
forever.**

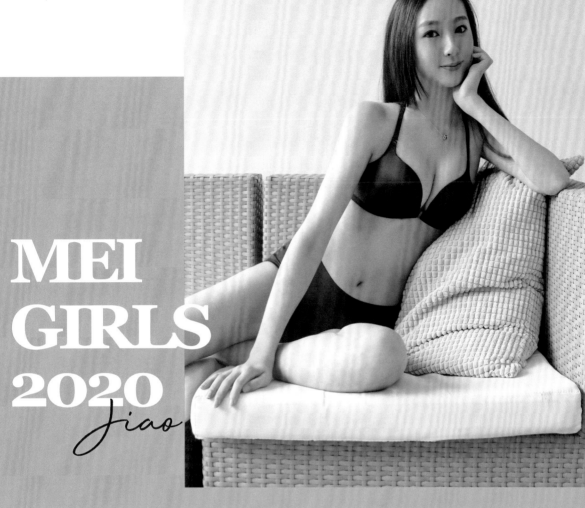

MEI
GIRLS
2020
Jiao

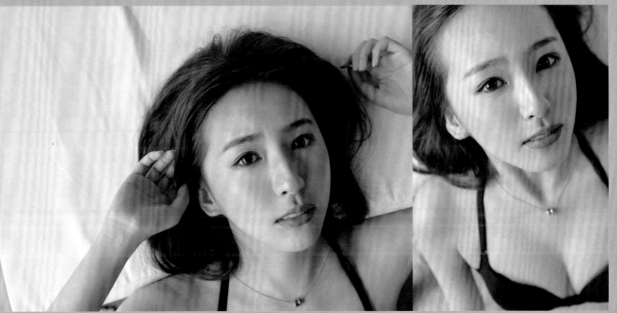

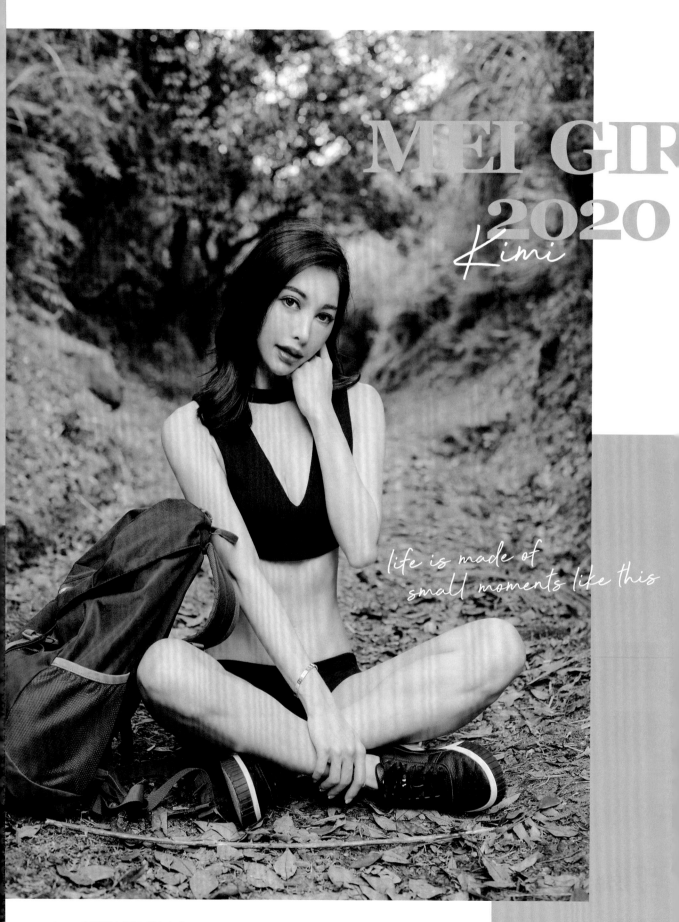

MEI GIR
2020
Kimi

life is made of
small moments like this

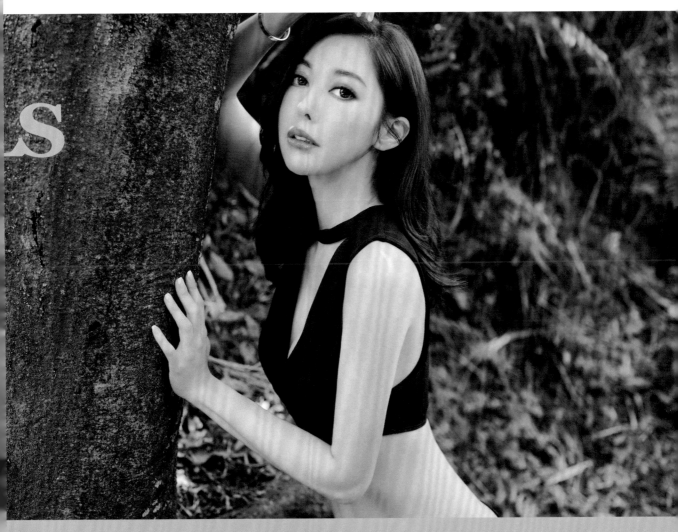

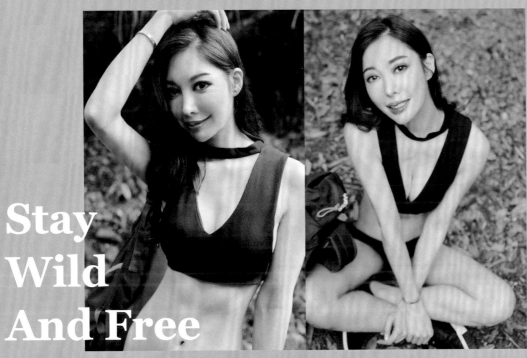

Stay
Wild
And Free

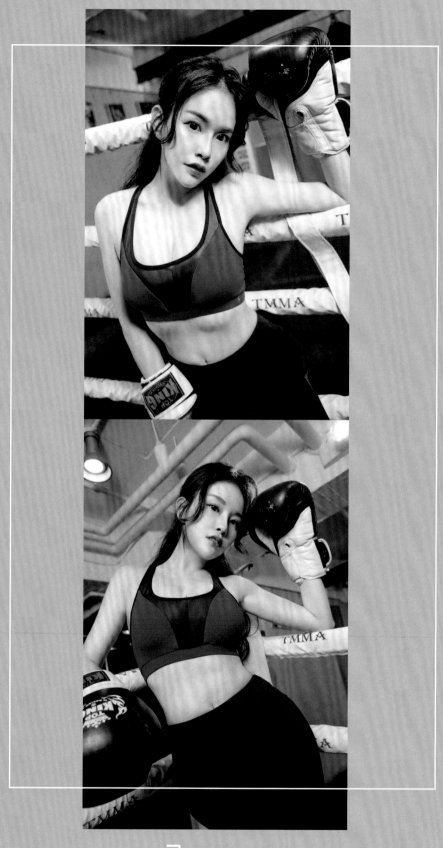

生活有點苦，不如加點我吧♥

MEI
GIRLS
✕
2020

糖可可
鄭苡玟

📷 instagram：@candyo3o5

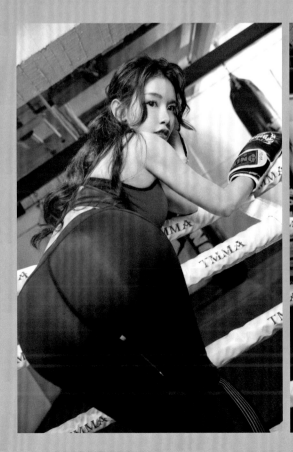
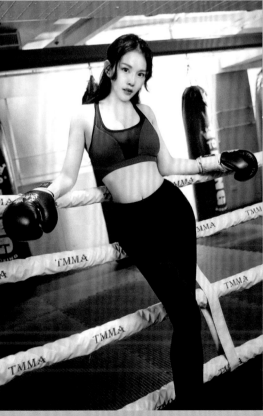

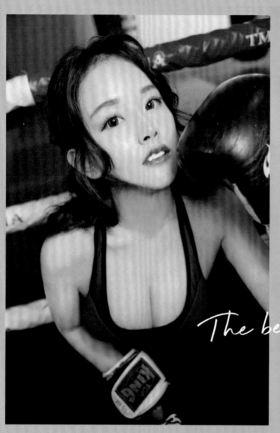

The best thing to hold onto in life is each other.

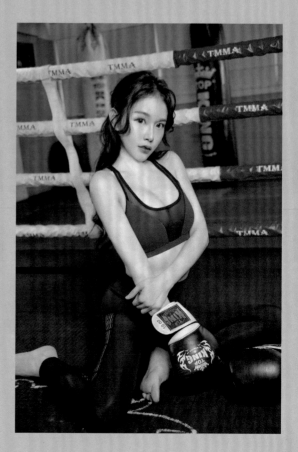

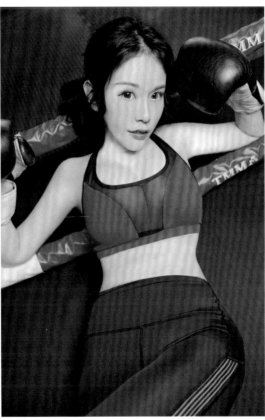

SPORTHOLIC

-

**I'm happy when
I'm with you**

Girl
Power

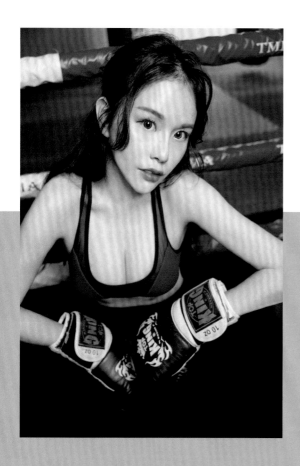

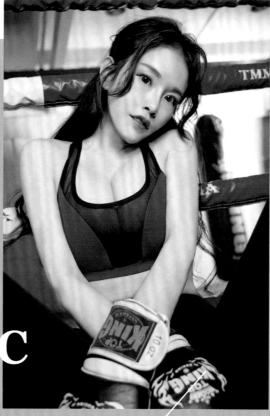

SPORTHOLIC

-

*I'm happy when
I'm with you*

Taiwan Top 100 Girls

2020

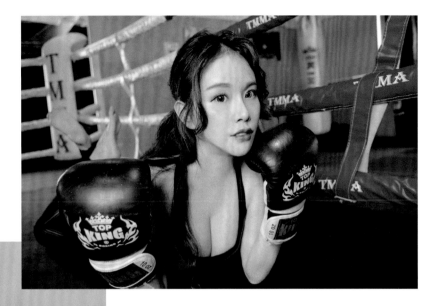

Girl
Power

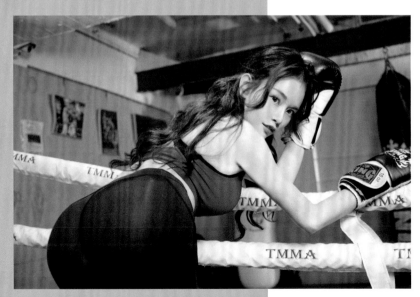

**MEI
GIRLS
2020**

-

Angel Energy

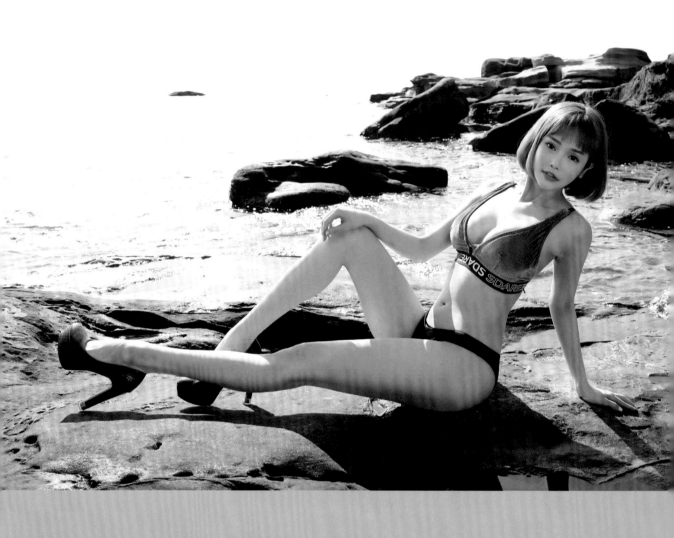

如果你老是嘴饞，你的 0 食在這♥

MEI
GIRLS
✕
2020

Ling Ling

📷 instagram : @zero_zero_ling

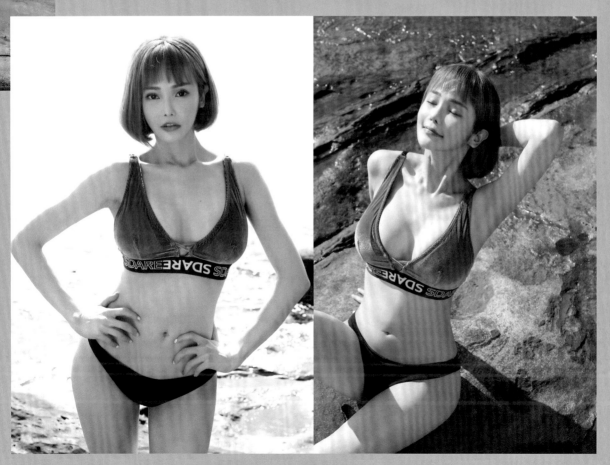

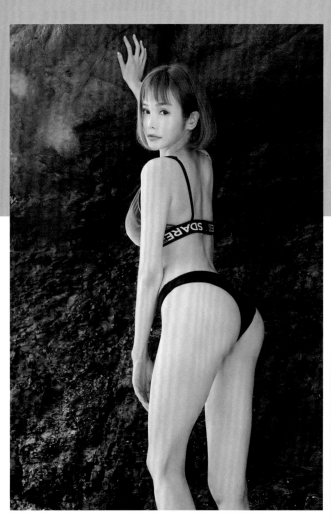

Taiwan
Top 100 Girls Album

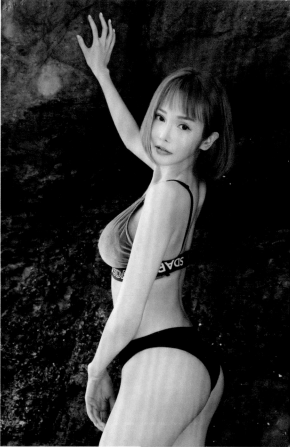

MEI
GIRLS
2020
Ling Ling

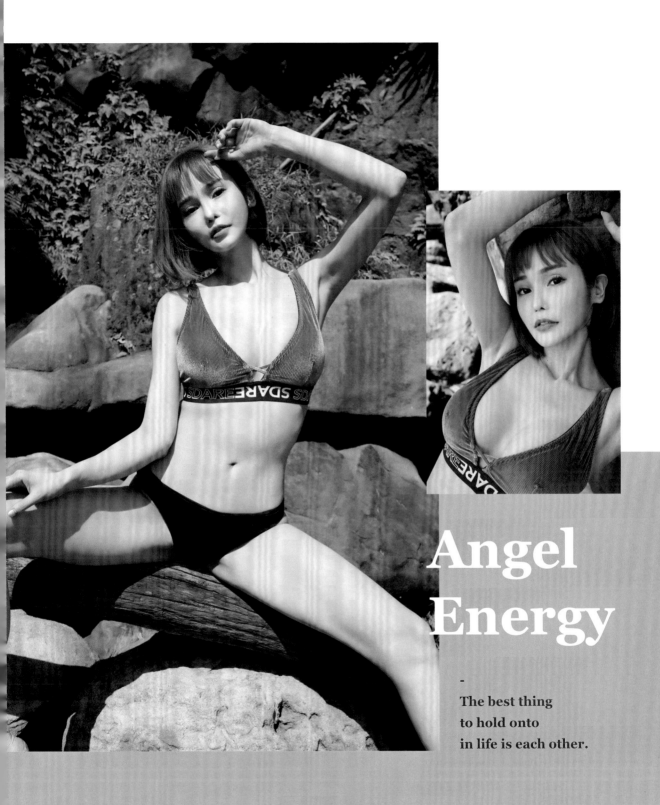

Angel
Energy

-

**The best thing
to hold onto
in life is each other.**

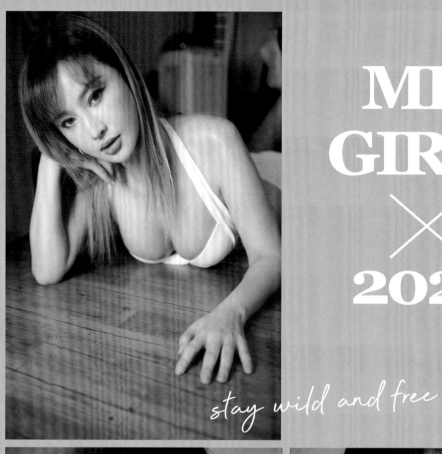

MEI
GIRLS
✕
2020

stay wild and free

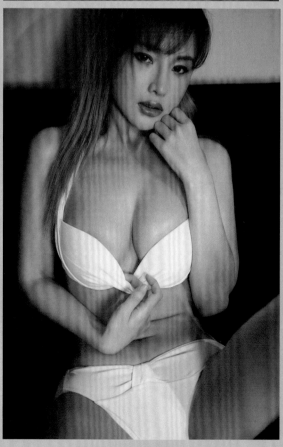

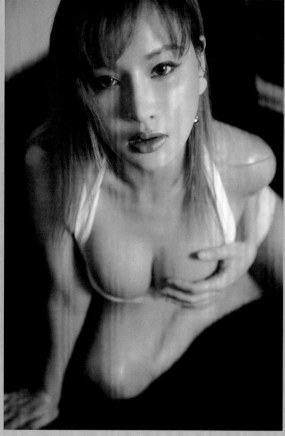

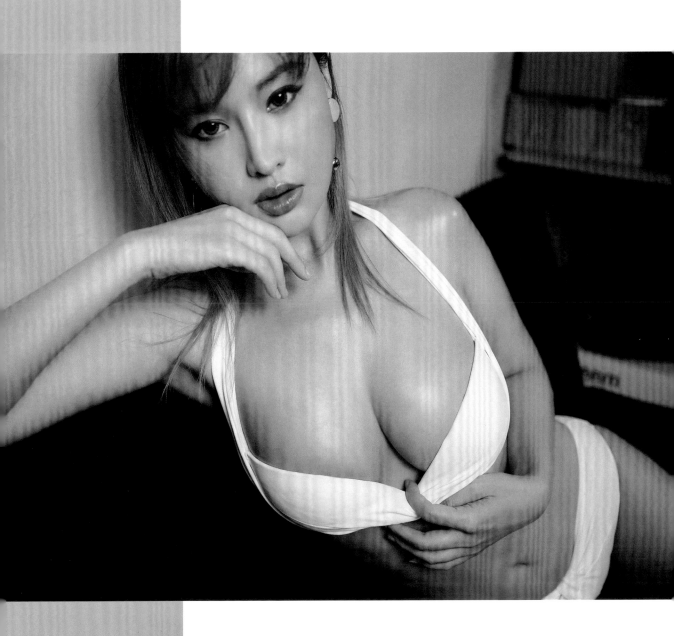

DAYDREAM

-

**Dream a little dream
of me**

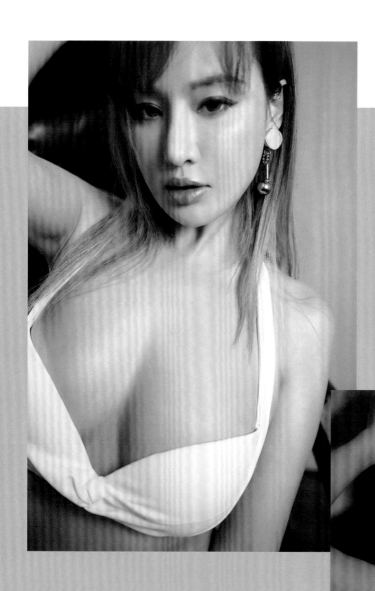

Best
Memories

-

Dream a little dream
Of me

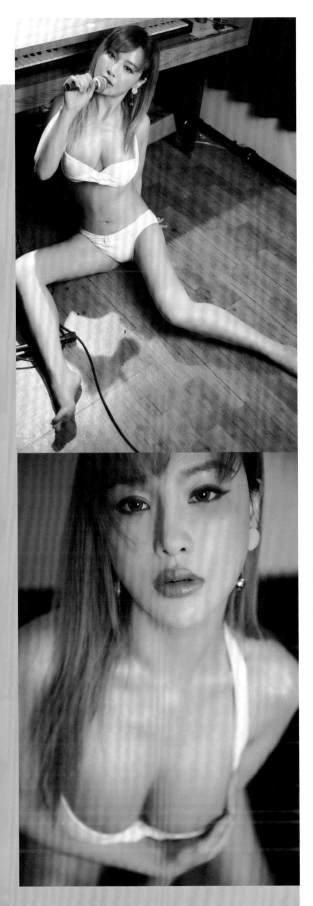

DAYDREAM

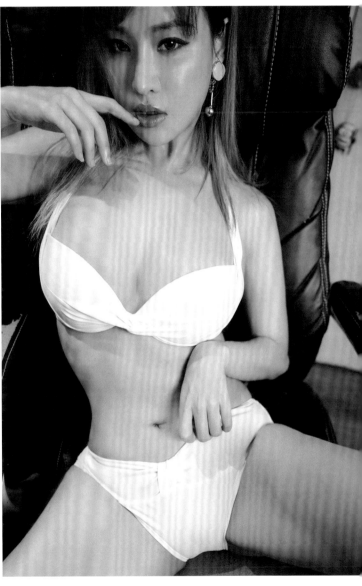

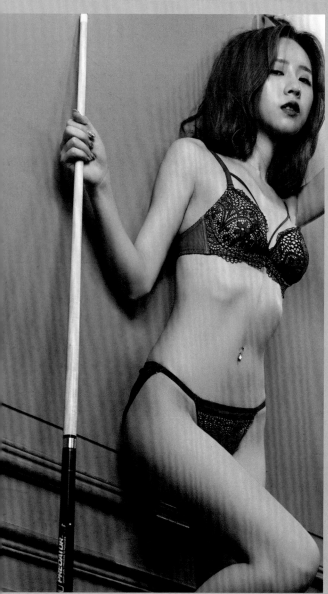

BE

HAPPY

ALWAYS

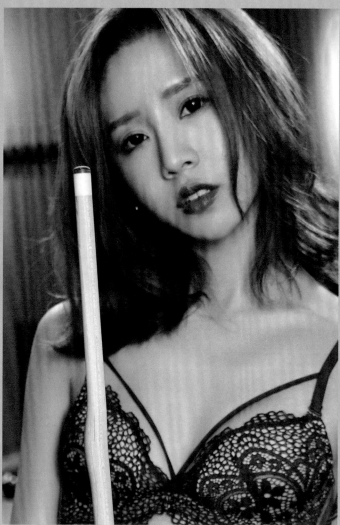

所有的事情在沒有結果前，
都是播種。

MEI
GIRLS
✕
2020

密寶
張筱密

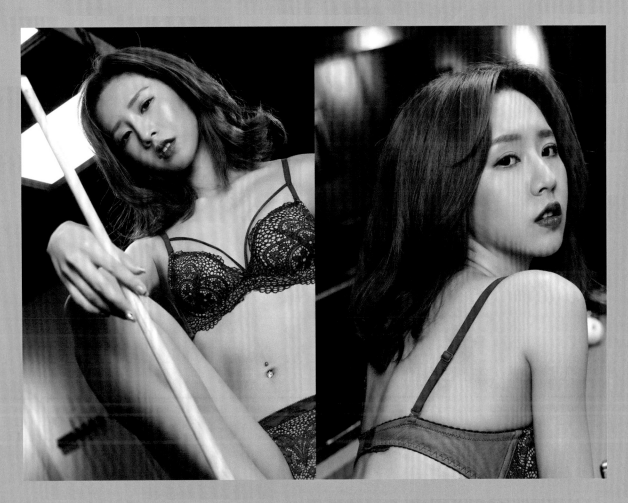

📷 instagram：@ltmimi

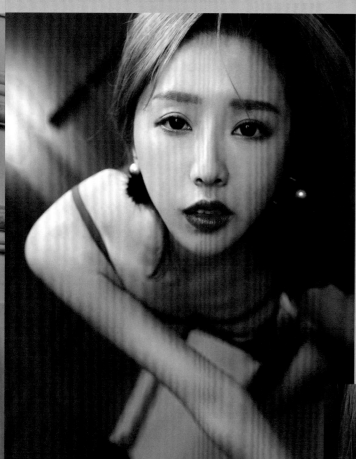

MEI
GIRLS
✕
2020

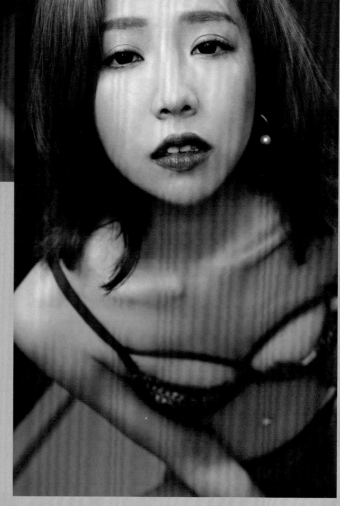

Closer
To
Happiness
Than I've
Ever Been

-

In your life my infinite
dreams live.

BE HAPPY

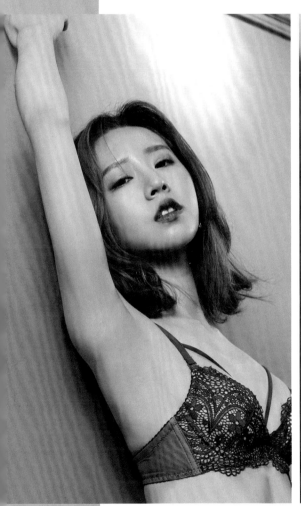

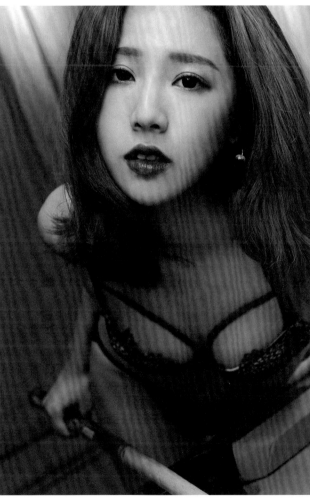

ALWAYS

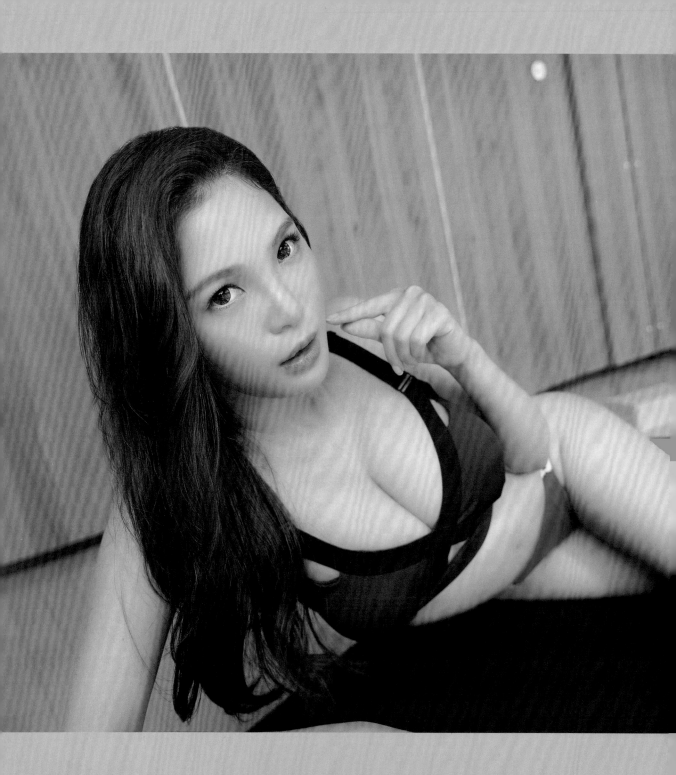

我等不及想再見到你♥

MEI
GIRLS
✕
2020

雪兒
Michelle

📷 instagram : @michelle19951212

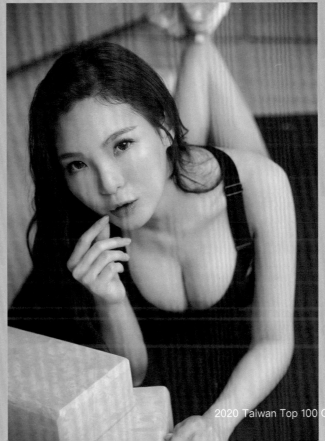

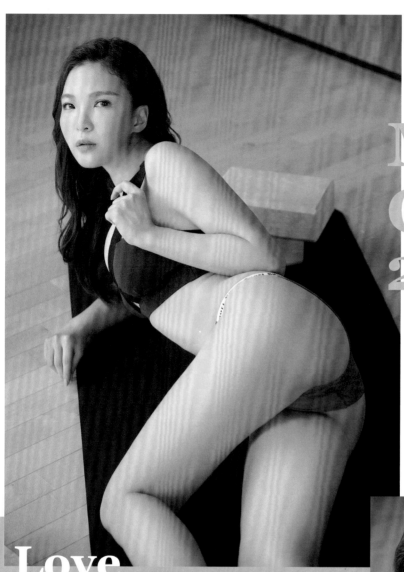

MEI
GIRLS
2020
Michelle

Love
Is An
Adventure

-
**You are my
New favorite feeling.**

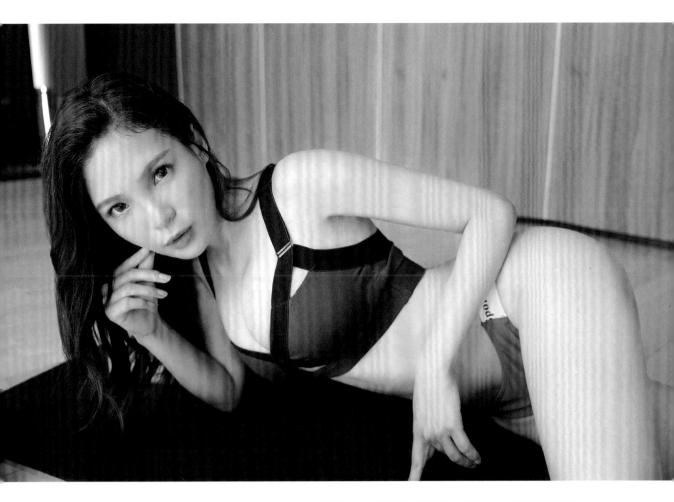

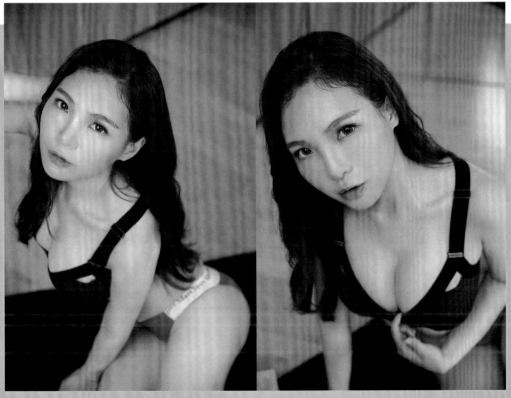

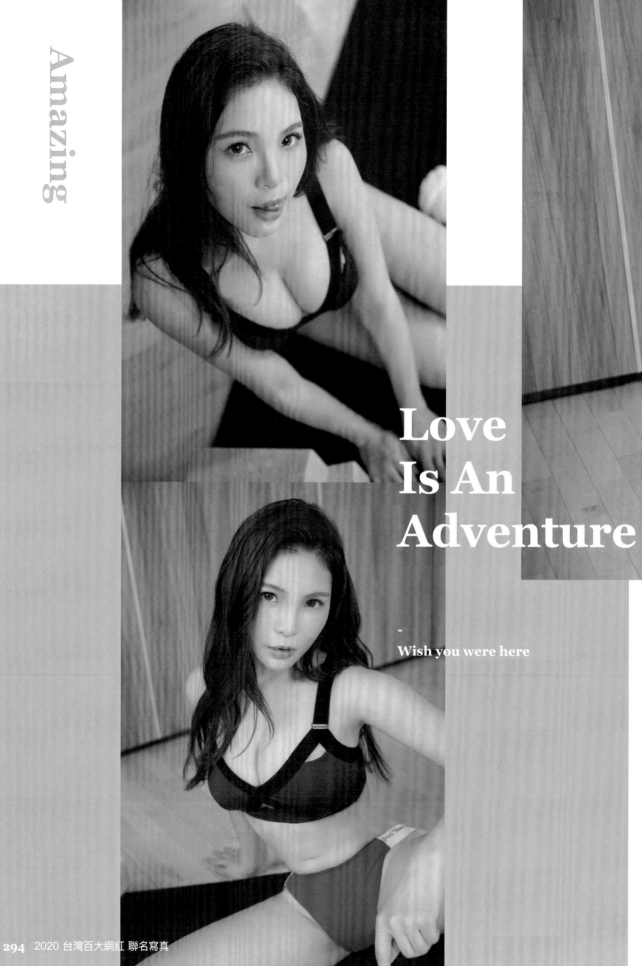

Amazing

Love Is An Adventure

-

Wish you were here

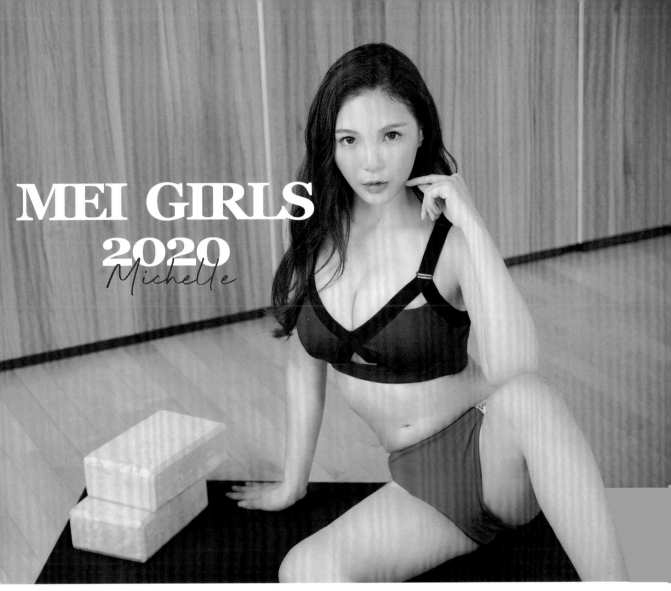

MEI GIRLS
2020
Michelle

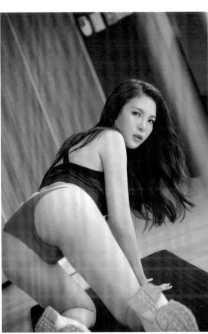

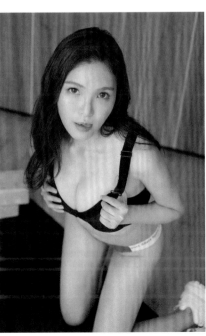

MEI GIRLS × 2020

瑄妹兒

Xuan

instagram：@milk08110811

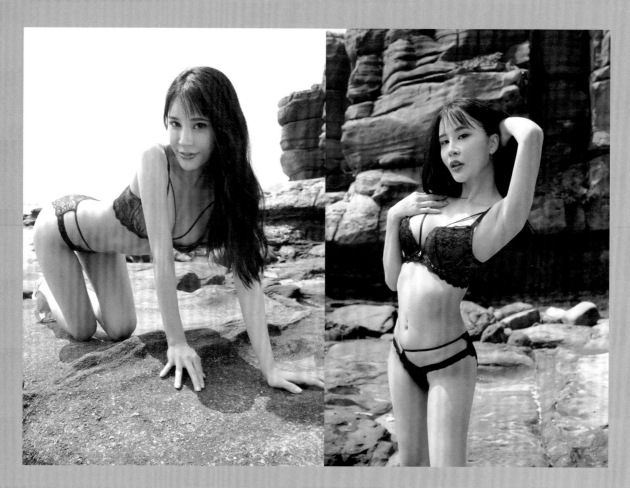

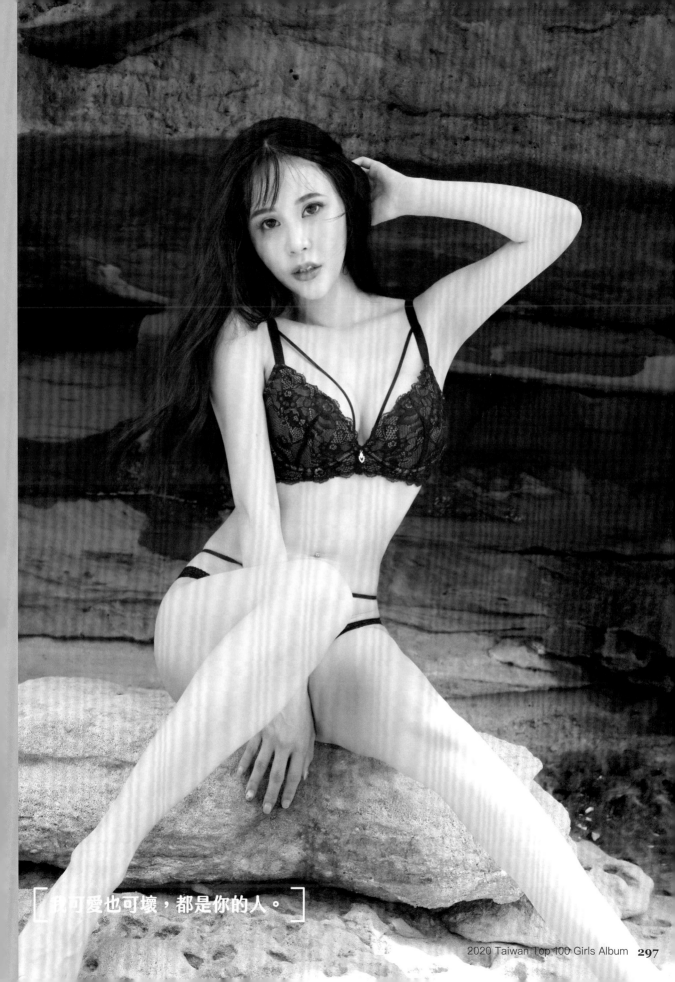

[我可愛也可壞，都是你的人。]

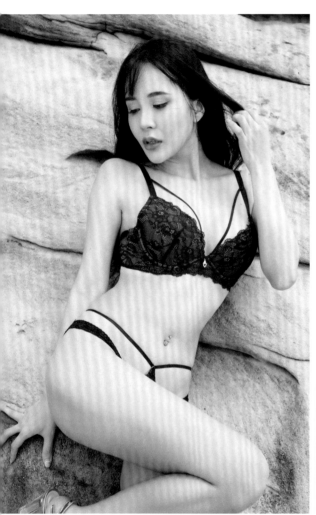

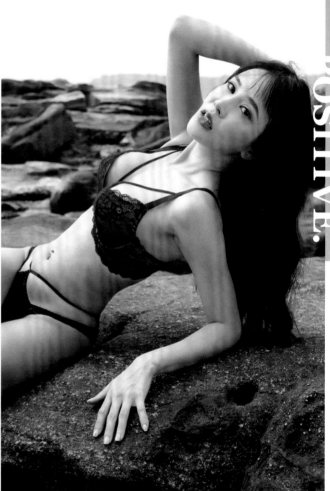

POSITIVE.

Summer
Vibes

-

Find joy in the journey.

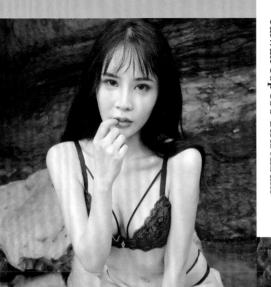

SUM —
MER

2 0 2 0

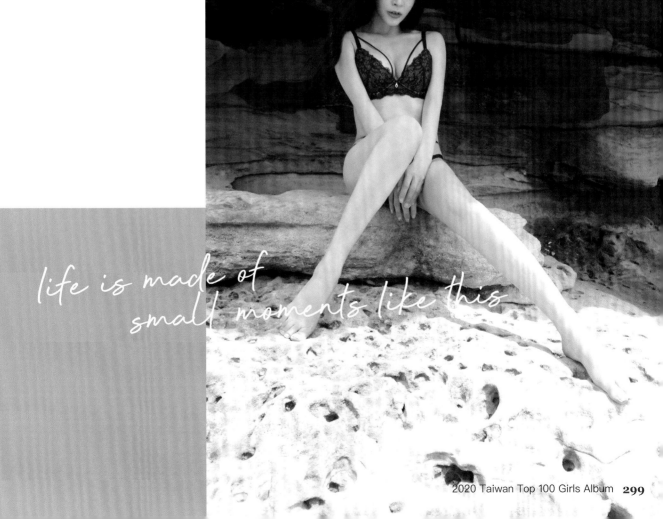

life is made of
small moments like this

MEI GIRLS 2020

Xuan

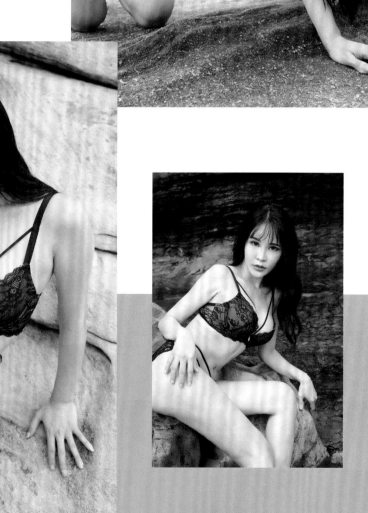

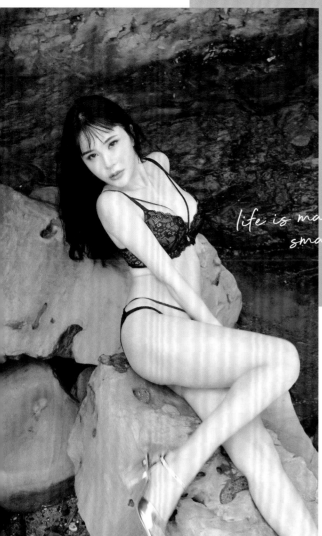

life is made of small moments like this

Summer
Vibes

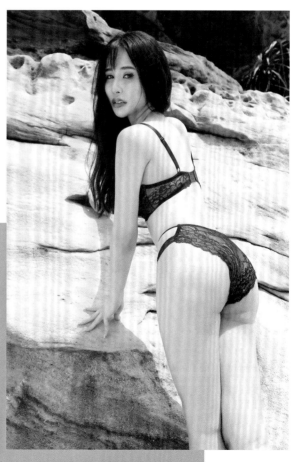

-

Find joy in the journey.

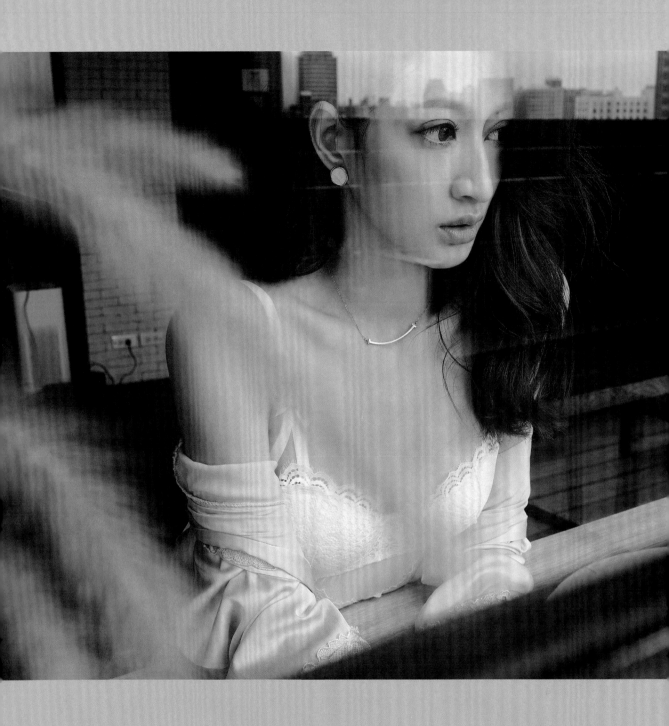

2020 好吃的東西要吃進肚子裡，
可愛的人要放在心裡！

MEI
GIRLS
✕
2020

凡凡

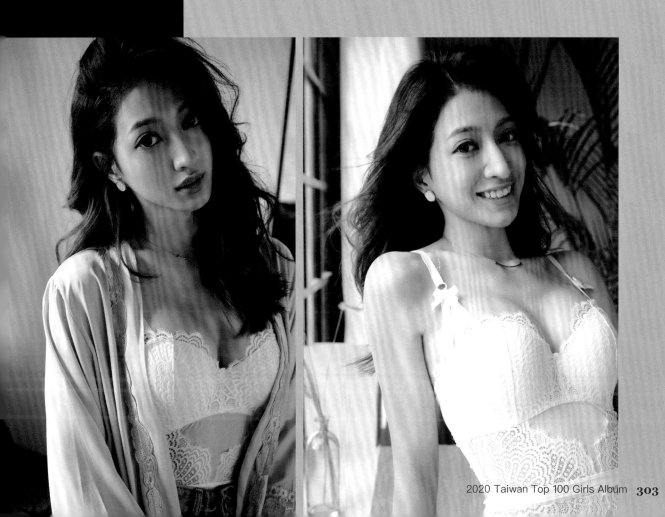

Ⓞ instagram : @eyvonne623

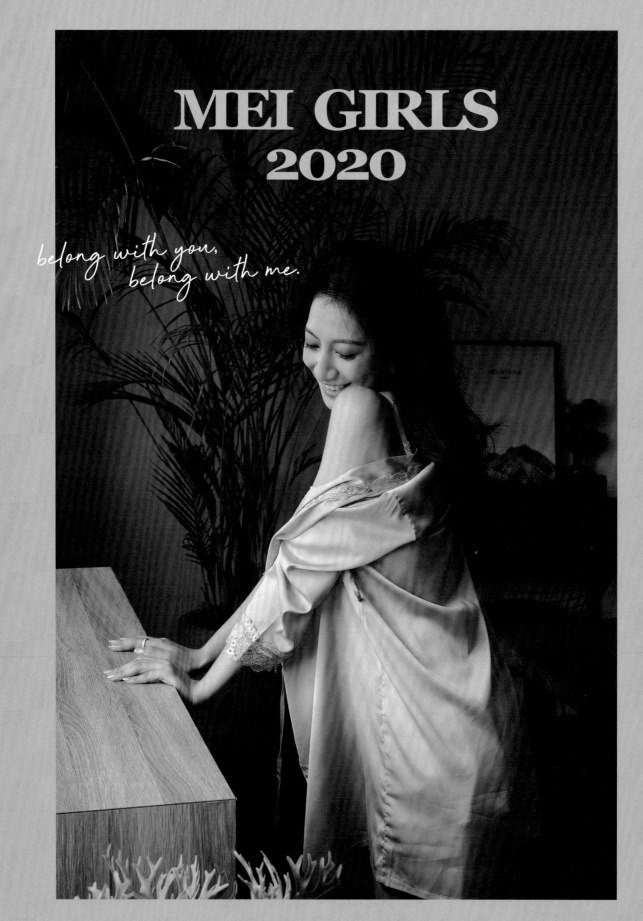

MEI GIRLS
2020

belong with you,
belong with me.

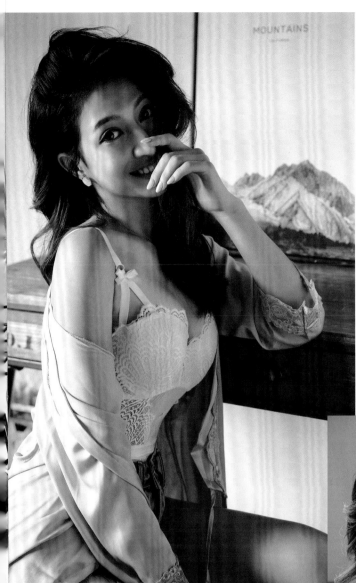

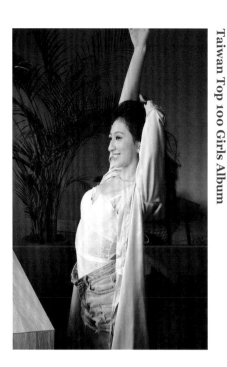

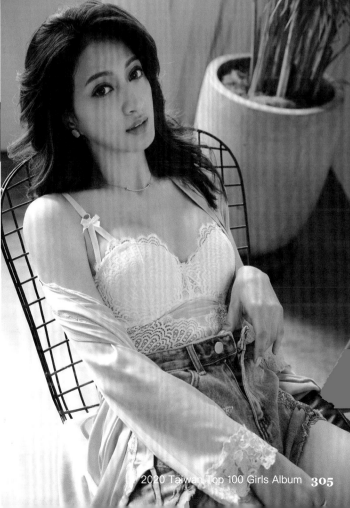

I Love
Seeing You
Happy

-

Closer to happiness
Than I've ever been.

MEI
GIRLS
✕
2020

馮苡珺

📷 instagram : @fengfeng.k

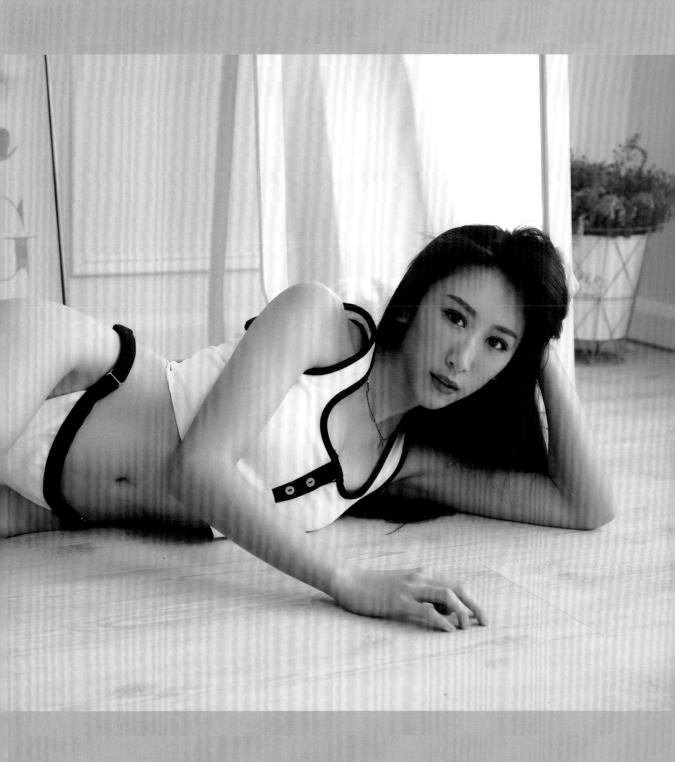

[2020 希望疫情趕快結束大家都平安]

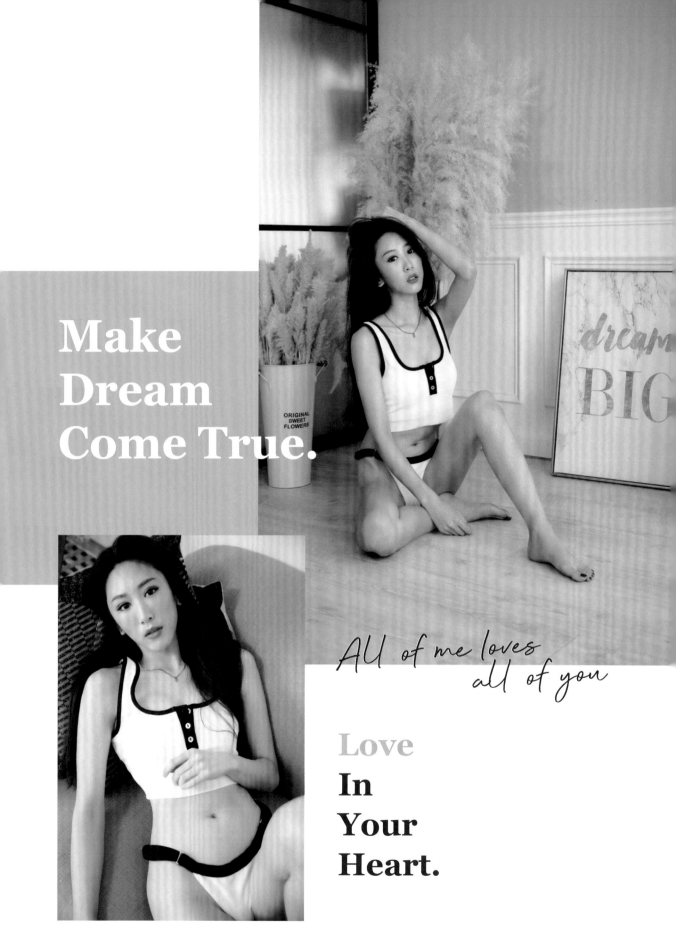

Make
Dream
Come True.

dream
BIG

ORIGINAL
SWEET
FLOWERS

All of me loves
all of you

Love

In

Your

Heart.

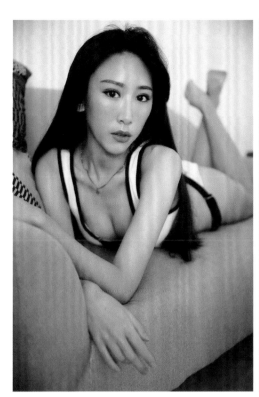
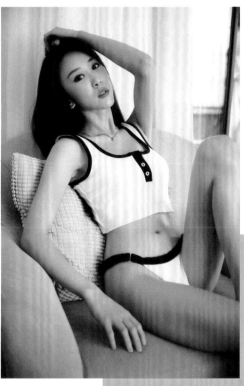

2020

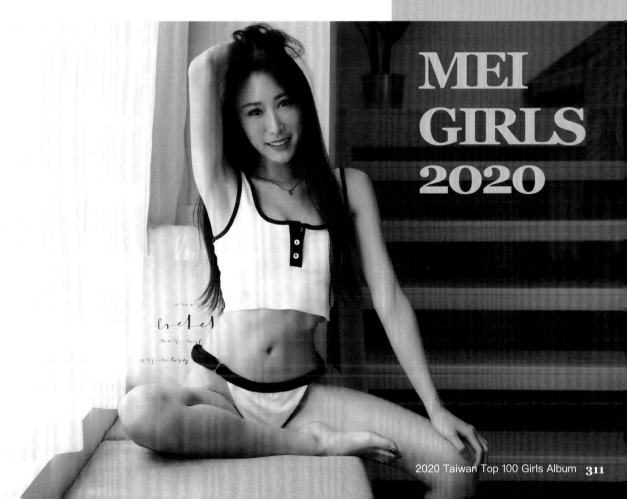

MEI
GIRLS
2020

You
Are My
Adventure

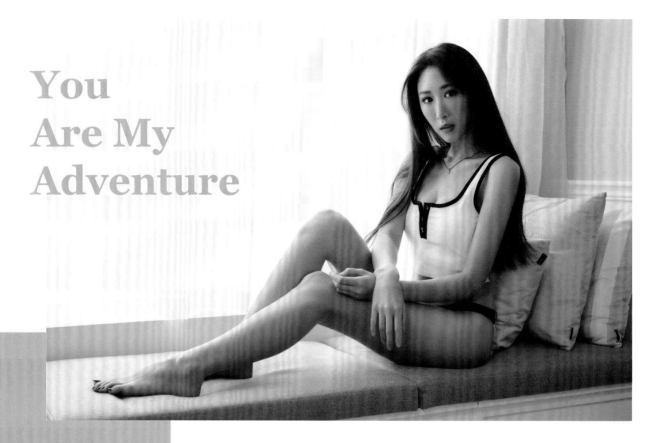

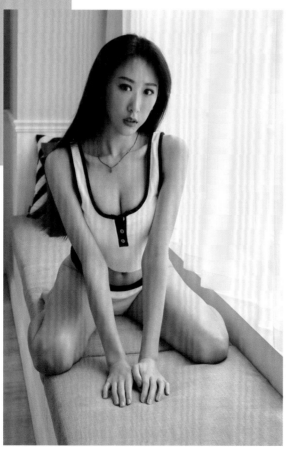

MEI
GIRLS
×
2020

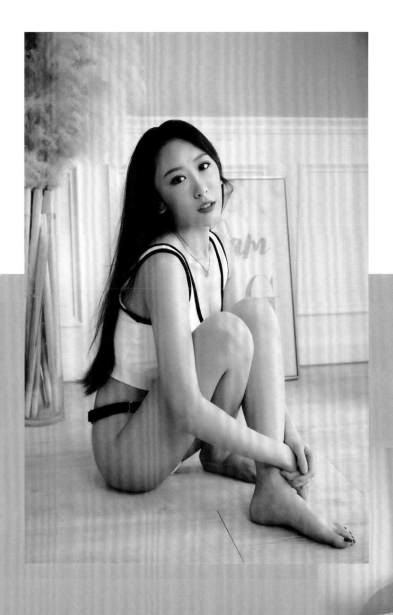

2020

Make Dream Come True.

-

Love In Your Heart.

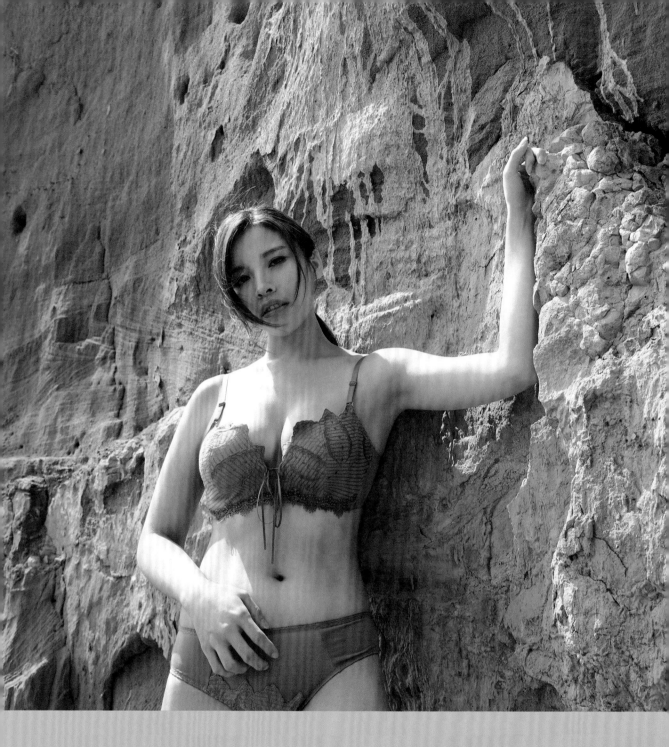

用微笑改變這個世界，
別讓這個世界改變你的微笑。

MEI
GIRLS
✕
2020

愛笑的

Alice

⟨instagram icon⟩ instagram：@alicelovevip

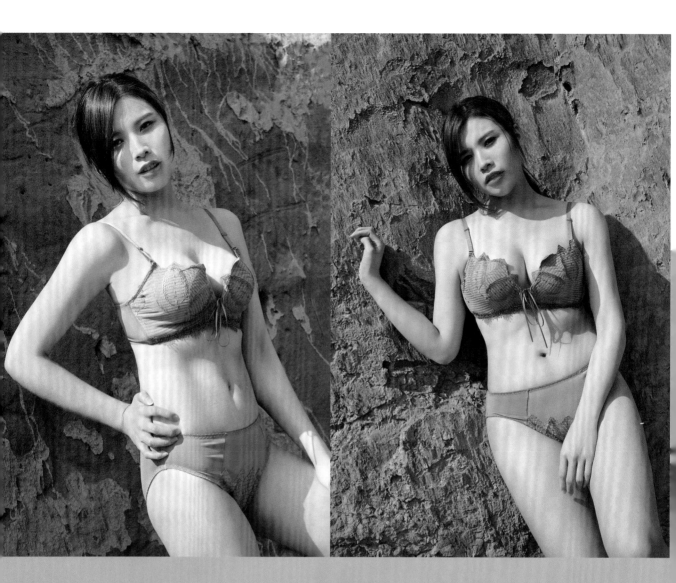

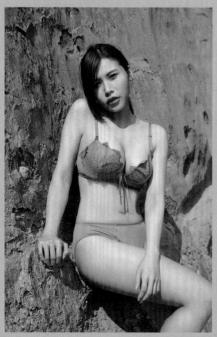

MEI
GIRLS
2020
Alice

-

find joy in the journey.

-
life is made of
small moments like this.

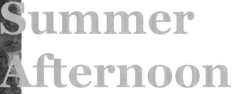

Summer
Afternoon

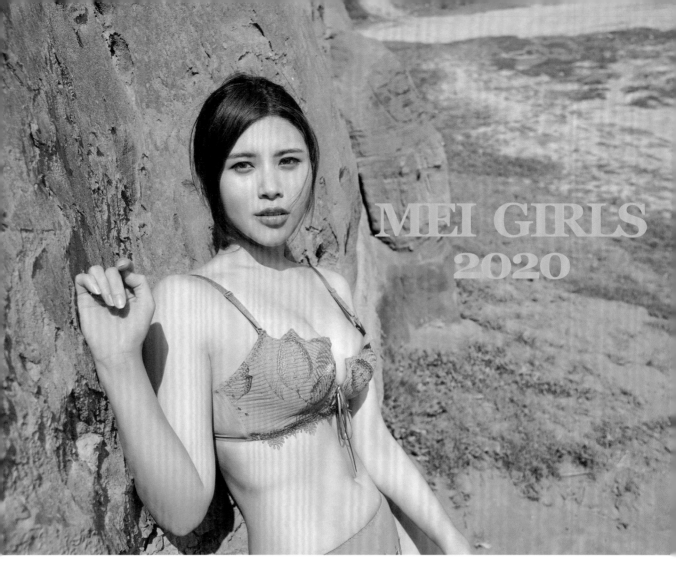

MEI GIRLS
2020

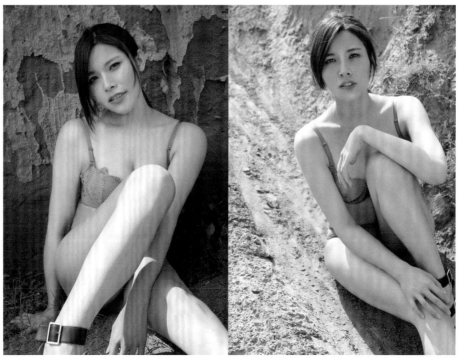

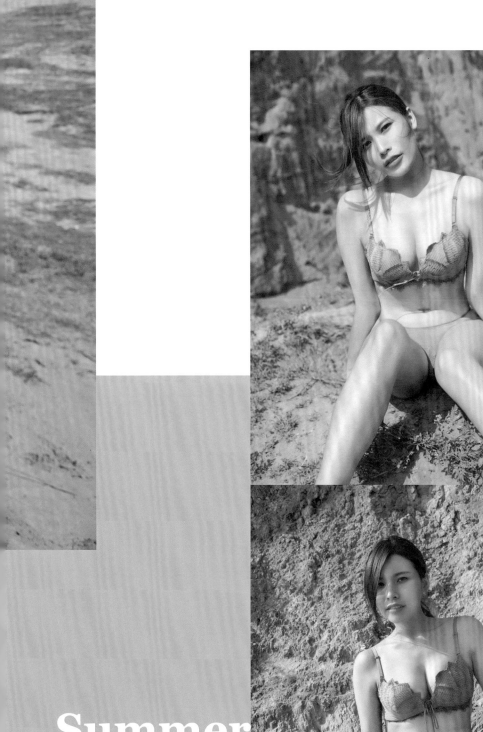

Summer
Afternoon

-
**life is made of
small moments like this.**

MEI
GIRLS
×
2020

大 *D*

instagram : @n.930__

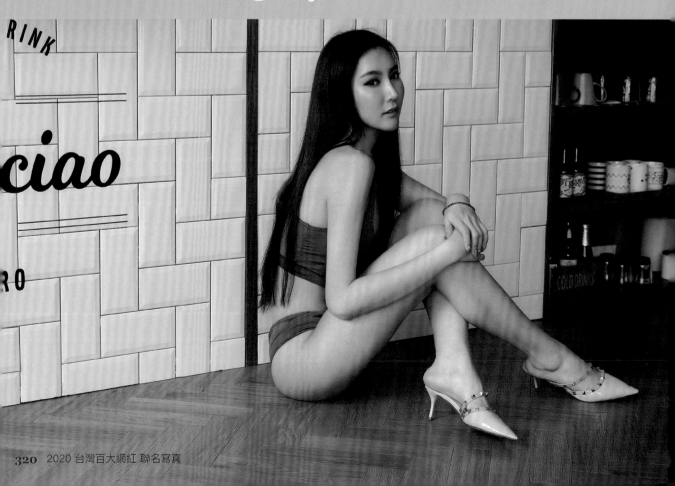

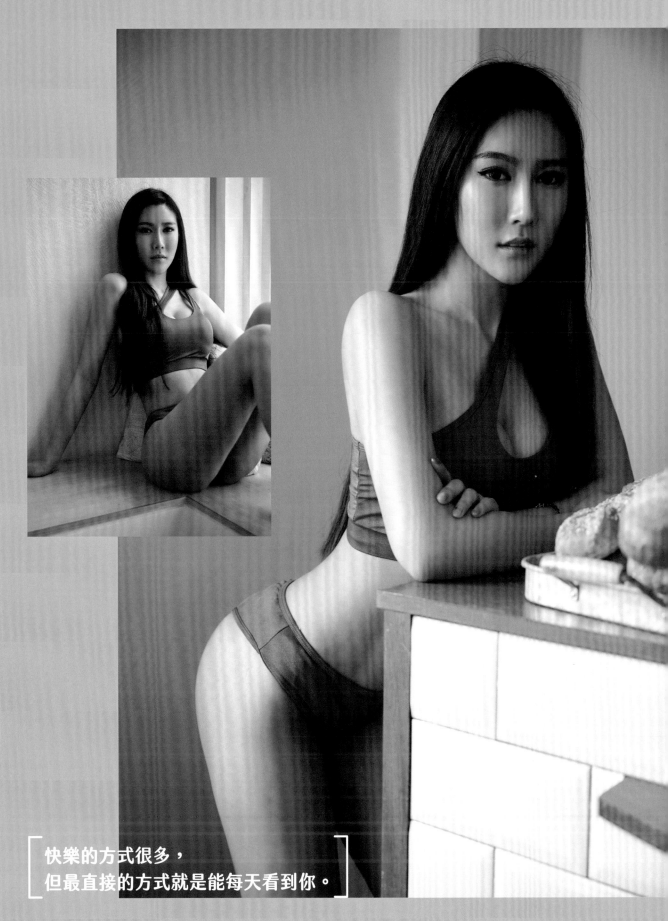

快樂的方式很多，
但最直接的方式就是能每天看到你。

MEI GIRLS
2020

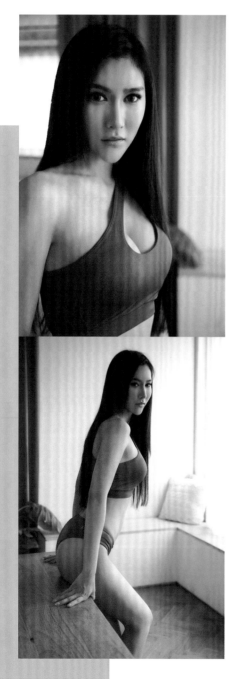

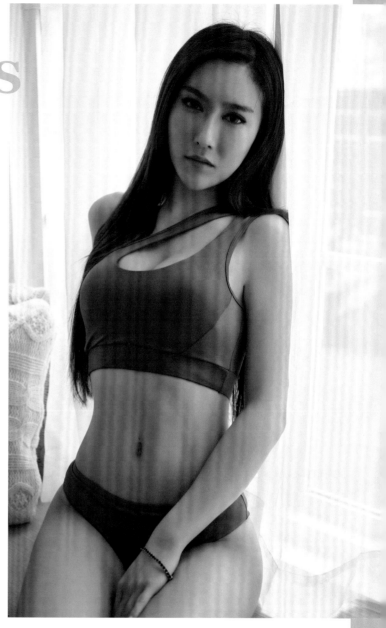

La Vie
Est Belle

-

You Are My Adventure.

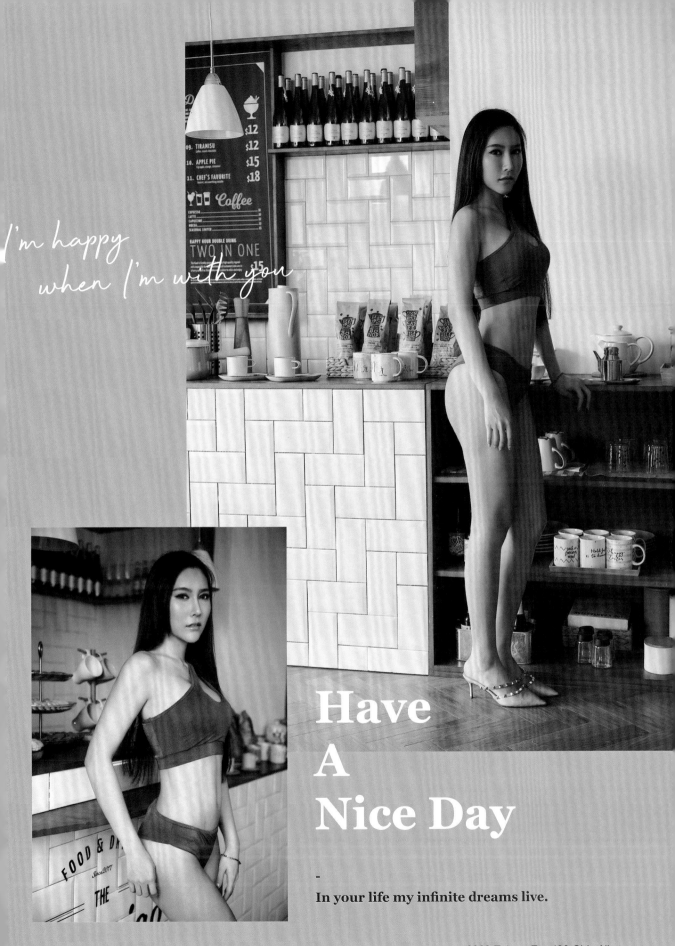

*I'm happy
when I'm with you*

Have
A
Nice Day

-

In your life my infinite dreams live.

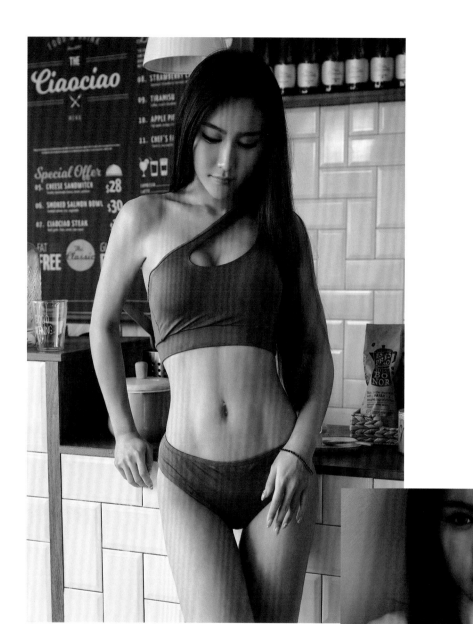

Have
A
Nice Day

-

In your life my infinite dreams live.

MEI GIRLS 2020

I'm happy when I'm with you

-

In your life my infinite dreams live.

MEI GIRLS

✕

2020

凱拉

Kyra

instagram：@kyra.528

珍惜每個特別的相遇包括你們。

MEI
GIRLS
2020
Kyra

-

**You are better
than
all anything**

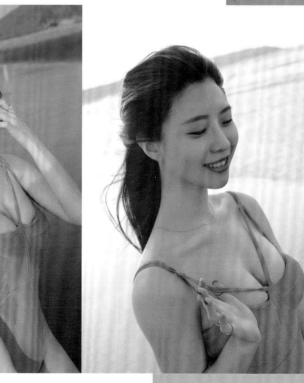

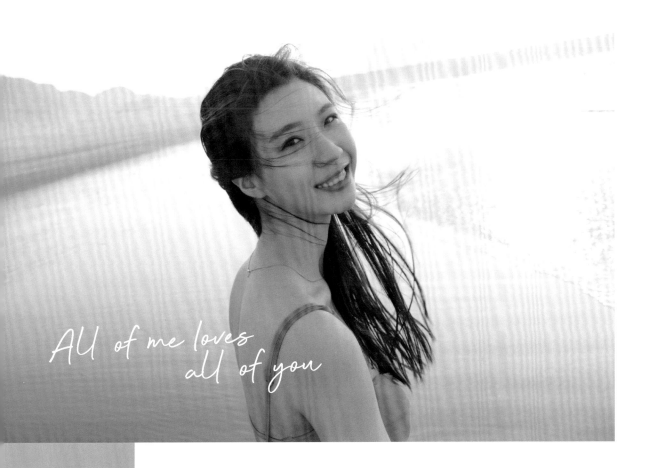

All of me loves all of you

Sunset
Girl

-

**I long to be a sunflower,
a lover of golden light,
a creator of sweet laughter.**

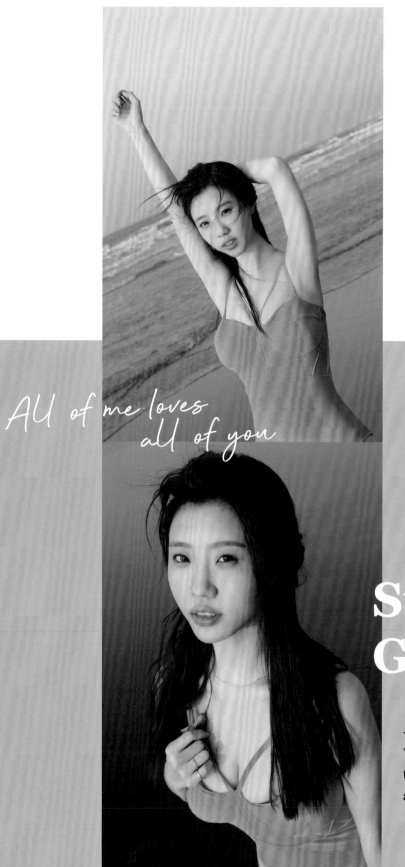

All of me loves
all of you

Sunset
Girl

-

**You are better
than
all anything**

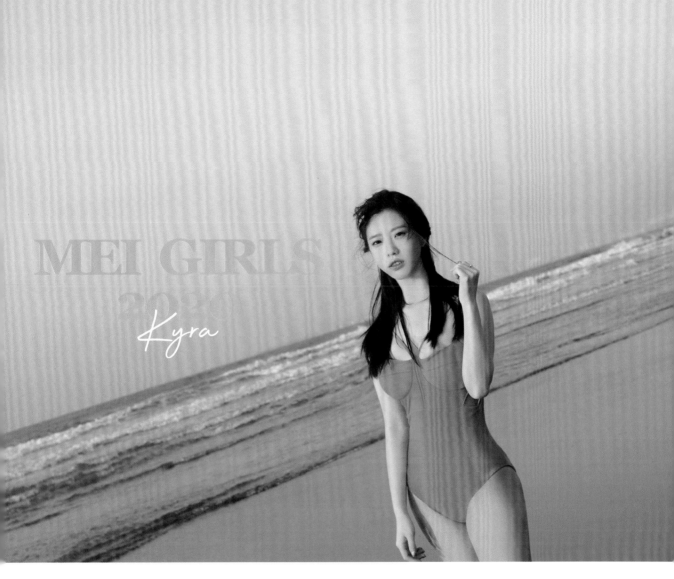

MEI GIRLS
2020

Kyra

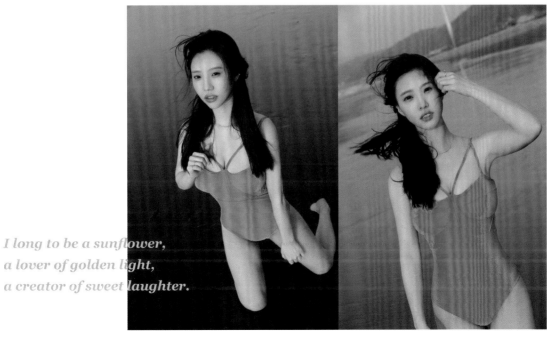

I long to be a sunflower,
a lover of golden light,
a creator of sweet laughter.

媚娘兒
Mei Girls

書　　名｜2020 台灣百大網紅聯名寫真
總 編 輯｜陳豪
副 編 輯｜沈琪琪
發行單位｜名媚國際股份有限公司
企劃團隊｜紅紅數位股份有限公司
協力單位｜捷喜多媒體數位股份有限公司
　　　　　熱浪新媒體股份有限公司
攝影團隊｜Zhuo Zheng Song Photo Studio
美編設計｜B.H Studio
整體造型｜FF Fashion Styling Studio
特別感謝｜S'dare Sport
印　　數｜二冊精裝套書
出版年月｜2020 年 9 月
I S B N｜978-986-99582-0-2

定價 – 新台幣 1580 元